"How necessary and wonderful to see ancient and beaut...
Cambridge singing with new life, colour and vitality through
the works of contemporary artists. A book to treasure."

Stephen Fry

❧

"How completely magnificent to see Cambridge through the eyes of
50 brilliant contemporary artists. Some of the pictures vividly remind me of
my time there. Bikes and wind basically. This book looks utterly lovely."

Claudia Winkleman

❧

"Cambridge is an inspiring city, rich in all kinds of beauty. It's wonderful to see such
a joyous celebration of the architecture, life and personality of this special place."

Dame Fiona Reynolds, Master of Emmanuel College, Cambridge

❧

"A stunning contemporary look at the city of Cambridge through the eyes of the
artists who are inspired by its architecture, green spaces, people and sense of history."

Sir David King, patron of the arts

❧

"A brilliant new look at contemporary Cambridge. A wide selection of local artists
have captured the energy, quirkiness and historic beauty of this wonderful city."

Jackie Ashley, President of Lucy Cavendish College

❧

"Just gorgeous: I found it irresistible."
Joanna Lumley

THE
CAMBRIDGE
ART BOOK

Published by UIT Cambridge Ltd

www.uit.co.uk

PO Box 145, Cambridge CB4 1GQ, England

Phone: +44 (0) 1223 302 041

Selection, Introduction, Foreword and Notes copyright © 2017 UIT Cambridge Ltd.

Images are copyright of their respective artists.

All rights reserved.

Subject to statutory exception no part of this book may be reproduced in any manner without the prior written permission of the publisher.

First published in 2017, in England.

ISBN: 978-1-906860-76-9 (hardback)

ISBN: 978-1-906860-78-3 (ePub)

ISBN: 978-1-906860-77-6 (pdf)

Also available for Kindle.

3 5 7 9 10 8 6 4 2

THE
CAMBRIDGE
ART BOOK

The City Through the Eyes of its Artists

EDITED BY

EMMA BENNETT

UIT
CAMBRIDGE

Acknowledgements

This book has been made possible by the enthusiasm of the contributing artists; to them I am eternally grateful.

An illustrious panel of local art and city experts selected the images chosen for publication and I am indebted to them for their help. They are:

- Louise Cummings *(Content Editor, Cambridge Magazine)*

- Glenn Dakin *(Comic artist; Aardman Animation, Marvel Comics and author of the Candle Man book series)*

- Lynn Fraser *(Communication consultant and writer)*

- Jane Horwood *(Award-winning web designer, Catfish Web Design)*

- Alice Ryan *(Head of Magazines and Features for Cambridge Magazine and Cambridge News)*

- Professor Martin Salisbury *(Director: Masters in children's book illustration, Cambridge School of Art, Anglia Ruskin University)*

- Patricia Seymour *(Education and Young Person's specialist)*

- Julia Moscardo *(Illustrator)*

I thank all at UIT/Green Books for their enthusiasm for the project. For their ongoing support, help and encouragement, I would also like to thank Craig, William and Molly Bennett, Lynn Fraser, Alison Schuldt, Len and Val Bennett and my Mom, Toni Smith.

CONTENTS

Foreword 6

Introduction 7

King's College and King's Parade 8

Around Cambridge 34

The River 71

Jesus Green to Parker's Piece 88

The Fitzwilliam Museum 97

Mill Road 99

Addenbrooke's 102

Cambridge University Botanic Gardens 104

The station and out of Cambridge 106

The Gog Magog Hills 110

The Orchard at Grantchester 112

Wicken Fen 114

The Fens towards Ely 116

Artists' credits 126

Artists 128

FOREWORD

Printmaking is about telling relevant contemporary stories with methods that are often traditional, and present tremendous technical challenges. But just like when someone learns to play a musical instrument, once the difficulties have been mastered, the results are astonishingly beautiful, sometimes sublime and often refreshingly poetical.

The Cambridge Printmakers are remarkably skilled at their craft, creating works that span all possible avenues of artistic expression, and this book beautifully documents the printmaking talent we're fortunate to have right here in Cambridge.

We live in a time when images are more often, and more easily, mass-produced than ever before. They are with us at all times, in our hand, in our pocket, and instantly shared globally. Our children use images as conversational tools, sending billions of images every day. But in this state of image overload, prints provide not only a refreshing contrast to the instant capture, but a refuge from the image commodity that documents but doesn't tell us anything.

A printmaker's work captures not an image, but an artistic expression, imbued with the artist's story, the artist's skills, and the process of the medium. We can look at a print, and find something new in it every time, as it lives on with us. As we change, we'll see new features, we'll uncover new thoughts that went into creating it.

This stands in stark contrast to the thoughtless stream of images we all have to wade through every day. Prints can clear our minds, can slow us down, and can make us reflect. Never before have we needed that more than today.

Jonas Almgren
CEO, Artfinder

INTRODUCTION

The Cambridge Art Book is both a contemporary art book and a guidebook showcasing one of the most beautiful cities in the world. Inspired by Cambridge's unique architecture and historic university, over 50 artists have produced a unique collection of contemporary images illustrating all aspects of the city and surrounding area. The city is shown in a new contemporary light through a range of media, from screen print and computer-aided design to hand-cut collage.

The map in the front of the book guides you to the places in the pictures. Wander around the city's cobbled streets, visit the beautiful village of Grantchester or make a trip to the nearby cathedral city of Ely. Along with your bicycle or walking boots, pack *The Cambridge Art Book* and see for yourself how local artists have reimagined these iconic places.

The "Artists' credits" section at the back of the book gives links to further information about all the artists. Have a look at the range of their work and see other images of the city and beyond.

It has been an honour to create such a fitting tribute to Cambridge and the amazing artists the city has inspired. Their creativity has made this book possible.

Emma Bennett

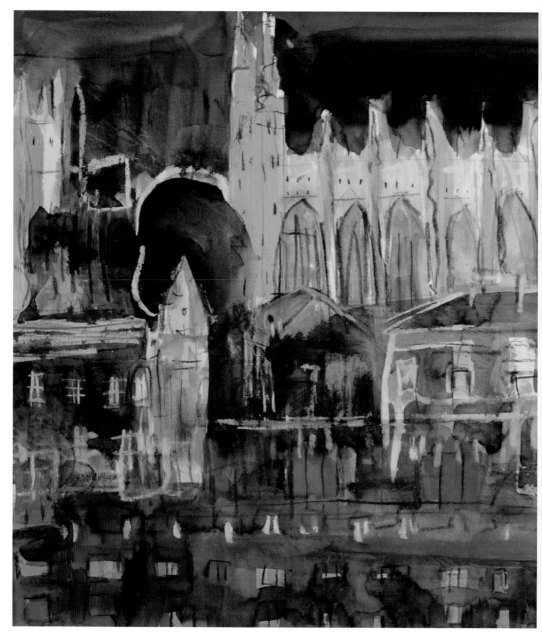

A View of Cambridge, Isobel Stemp

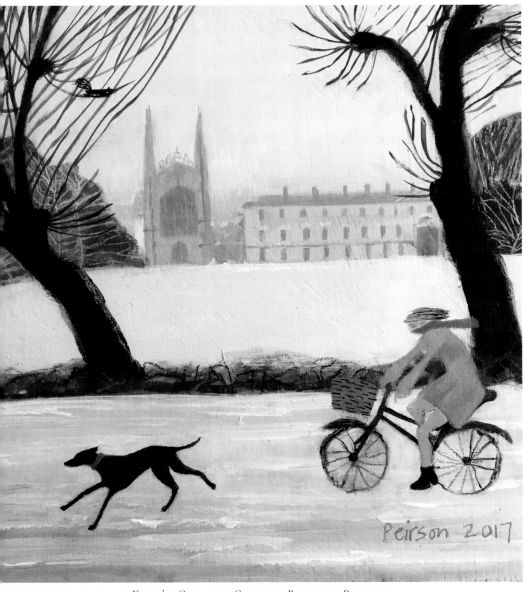

KING'S COLLEGE CHAPEL, BARBARA PEIRSON
OVERLEAF: KING'S COLLEGE AND AROUND, ALISON KING

UP UP and away

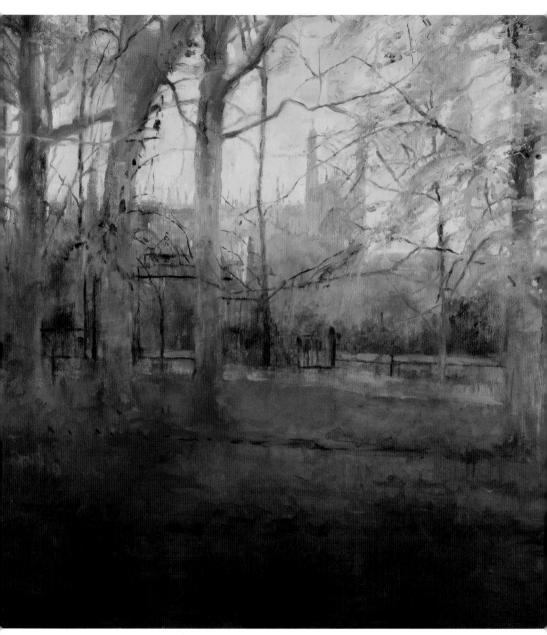

KING'S COLLEGE CHAPEL, ROSEMARY TRESTINI

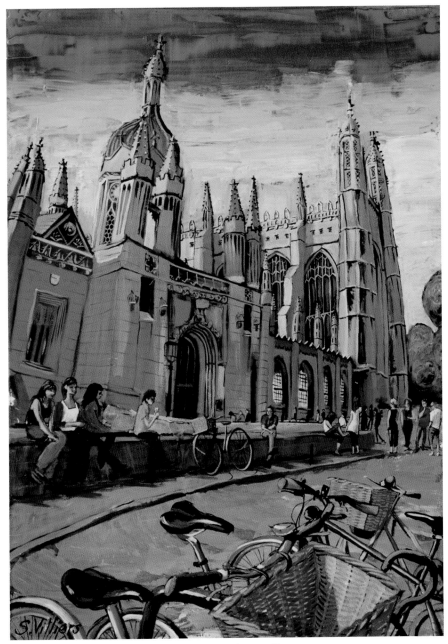

King's Parade, Sonia Villiers

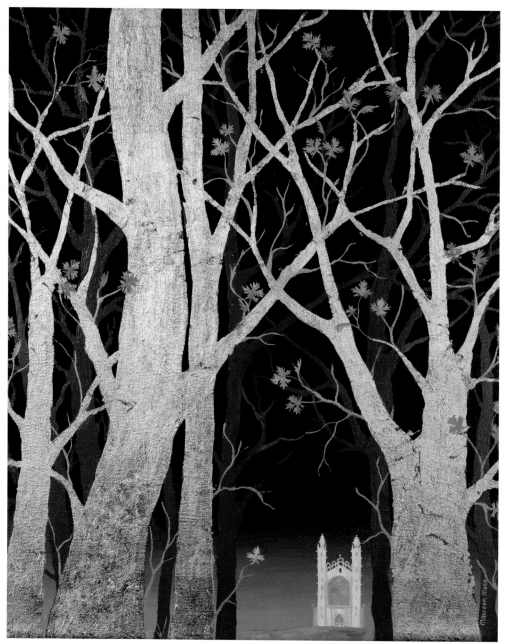

KING'S COLLEGE CHAPEL, MAUREEN MACE

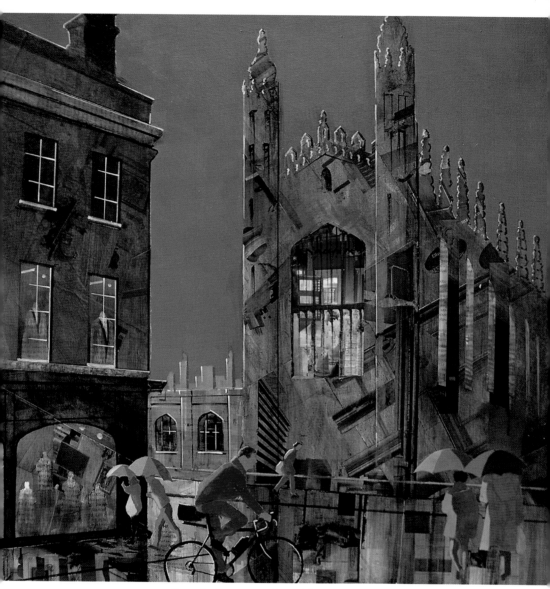

KING'S PARADE, JOHN TORDOFF
OVERLEAF: KING'S PARADE, CLARE CAULFIELD

15

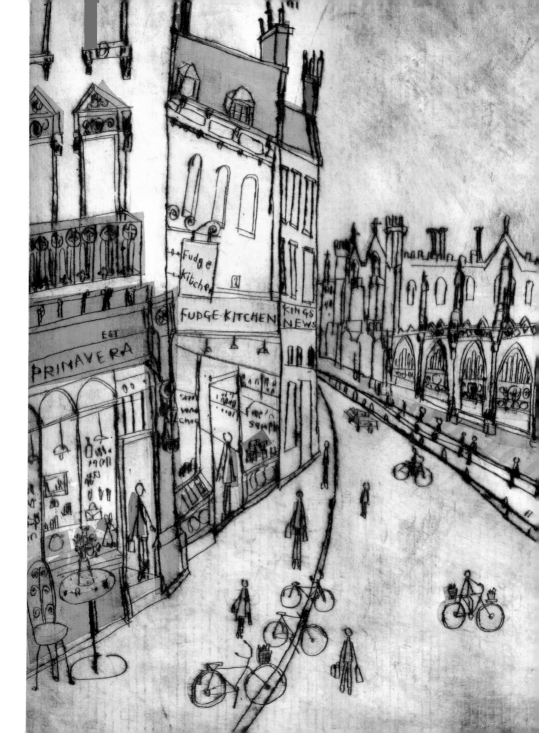

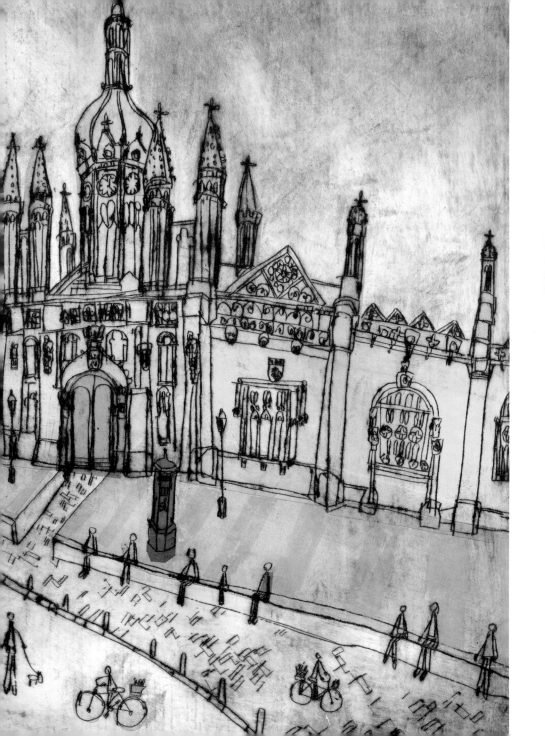

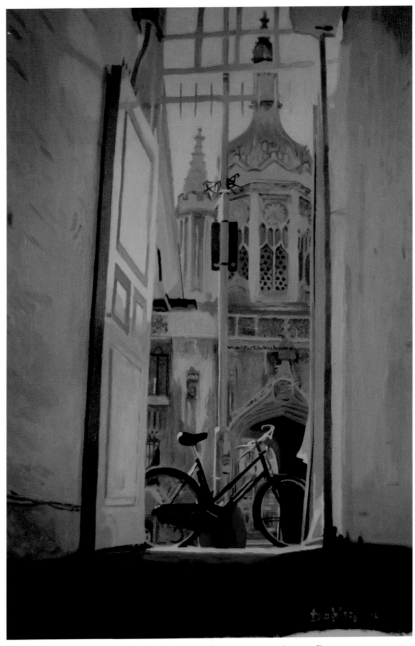

PASSAGEWAY ONTO KING'S PARADE, ANDY DAKIN

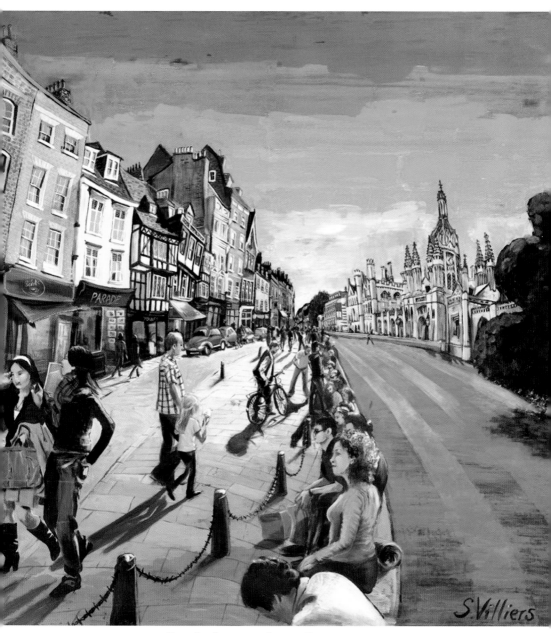

KING'S PARADE, SONIA VILLIERS
OVERLEAF: A PORTER'S LODGE, ANDY DAKIN

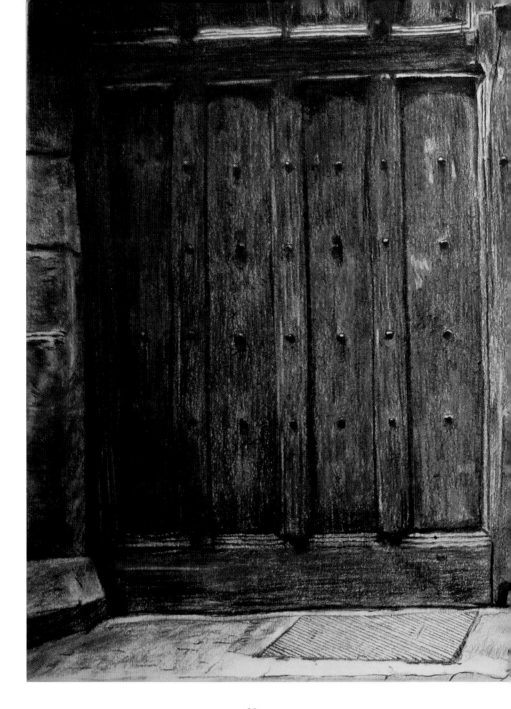

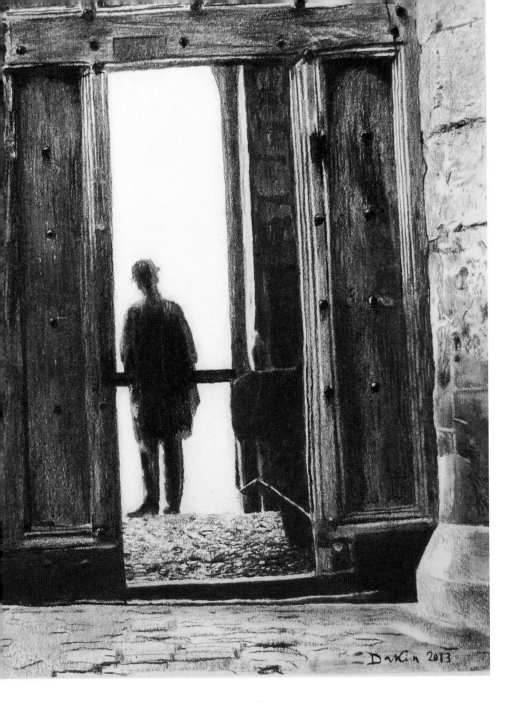

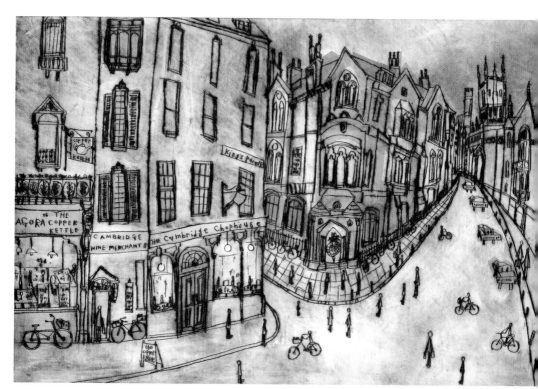

KING'S PARADE AND THE CORPUS CHRISTI CLOCK, CLARE CAULFIELD

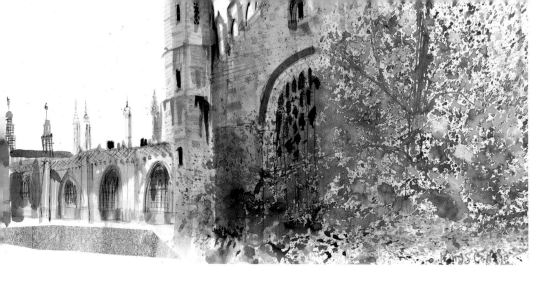

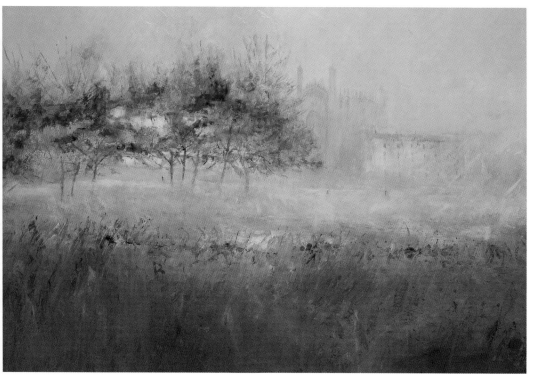

KING'S COLLEGE CHAPEL, ROSEMARY TRESTINI
ABOVE: KING'S COLLEGE, SAM BOUGHTON

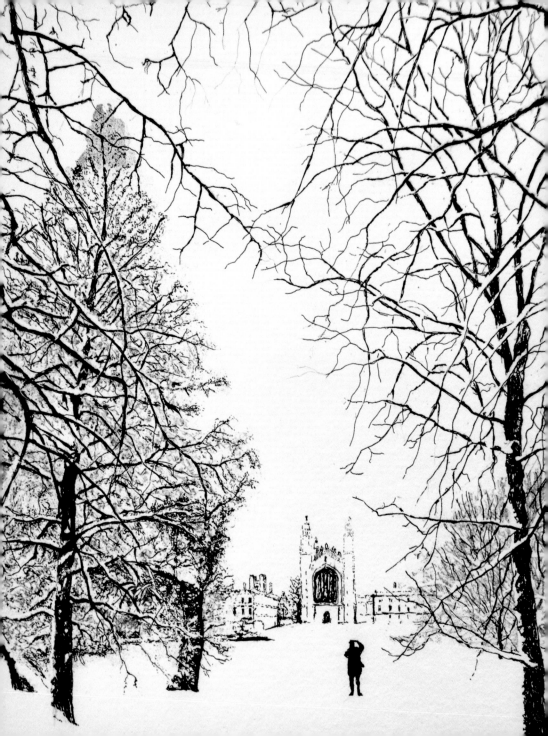

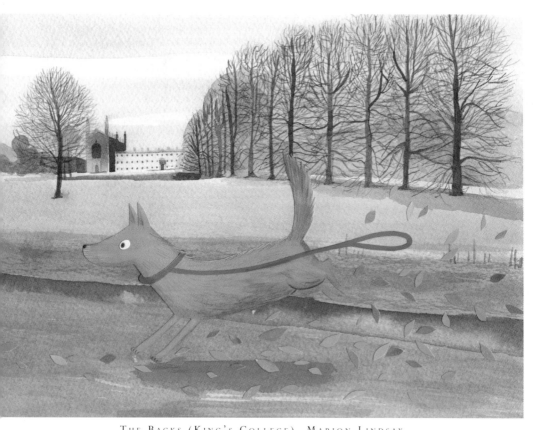

THE BACKS (KING'S COLLEGE), MARION LINDSAY
OPPOSITE: KING'S COLLEGE CHAPEL, JOHN PRESTON

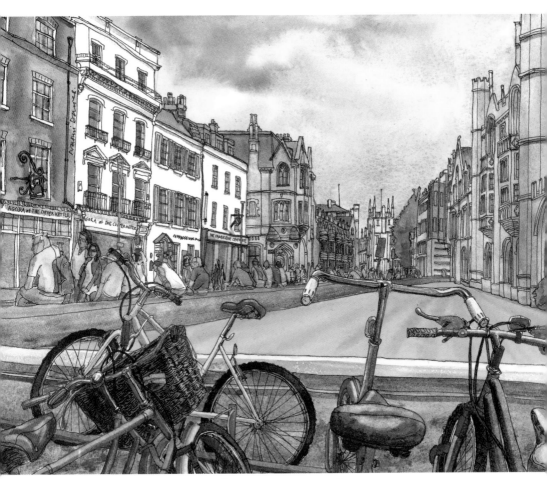

KING'S PARADE, NAOMI DAVIES

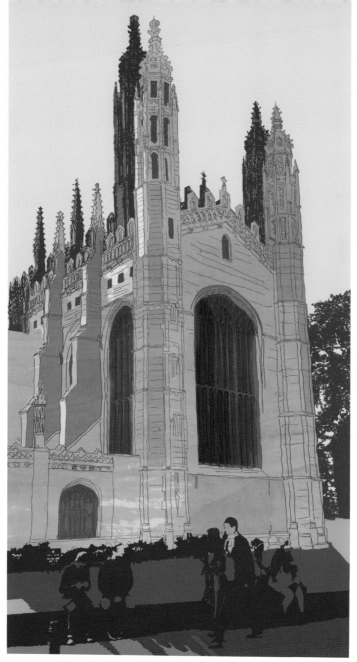

KING'S COLLEGE CHAPEL, IRYNA MASKO

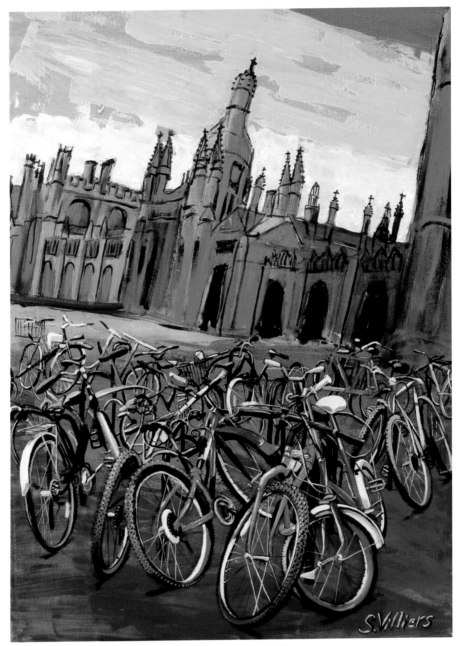

KING'S COLLEGE, SONIA VILLIERS

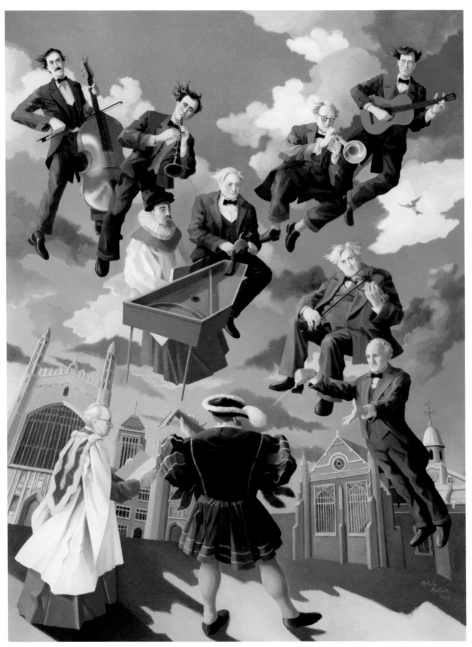

KING'S COLLEGE, OPHELIA REDPATH

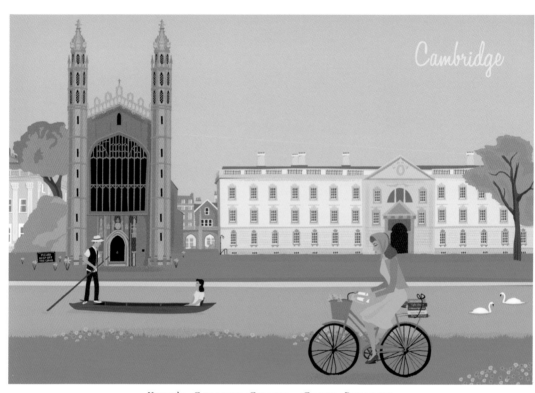

KING'S COLLEGE CHAPEL, CLARE PHILLIPS

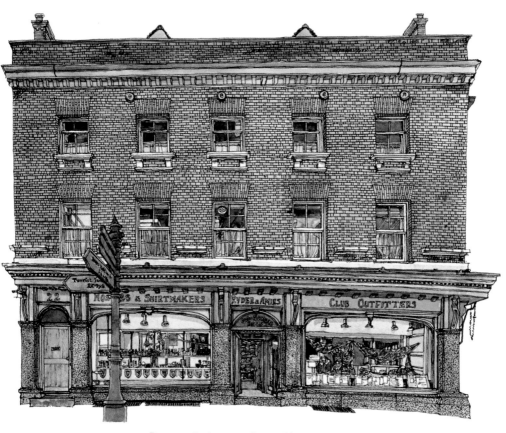

RYDER & AMIES, PAUL MARGIOTTA

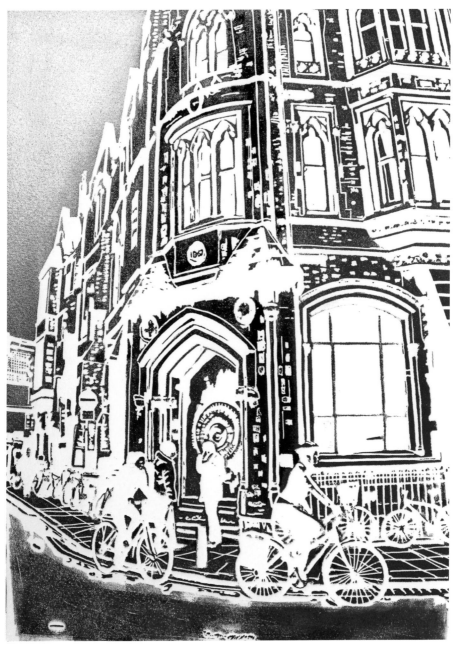

THE CORPUS CLOCK, KING'S PARADE, JO TUNMER

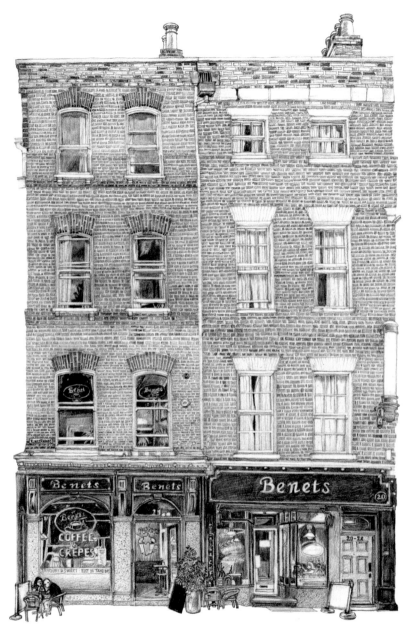

BENETS, KING'S PARADE, PAUL MARGIOTTA
OVERLEAF: THE MARKET SQUARE, REBECCA STARK

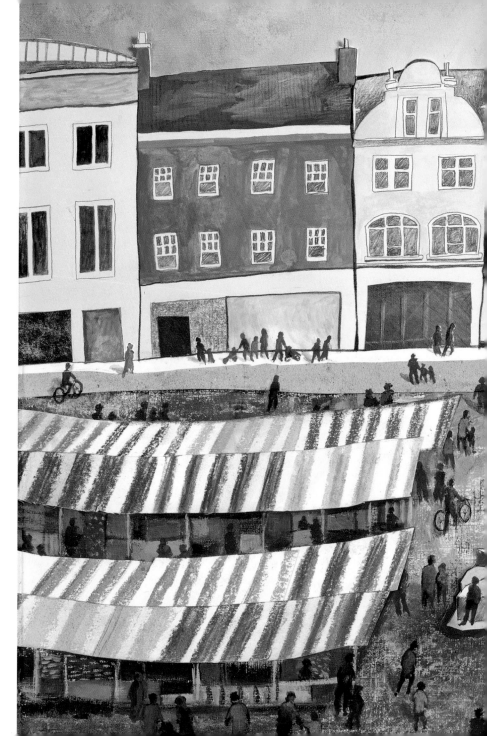

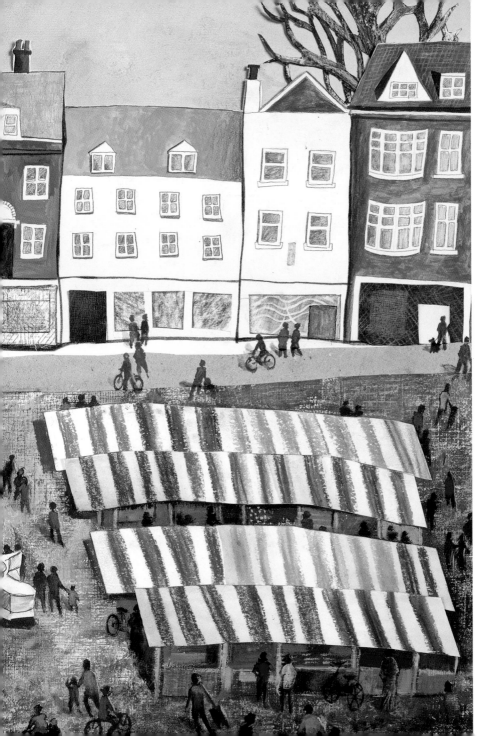

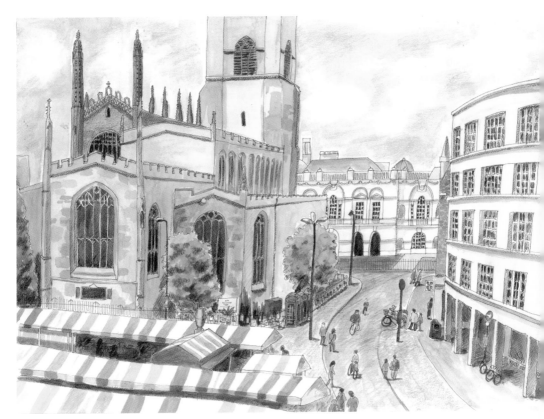

THE MARKET AND GREAT ST MARY'S CHURCH, SUE SMITH

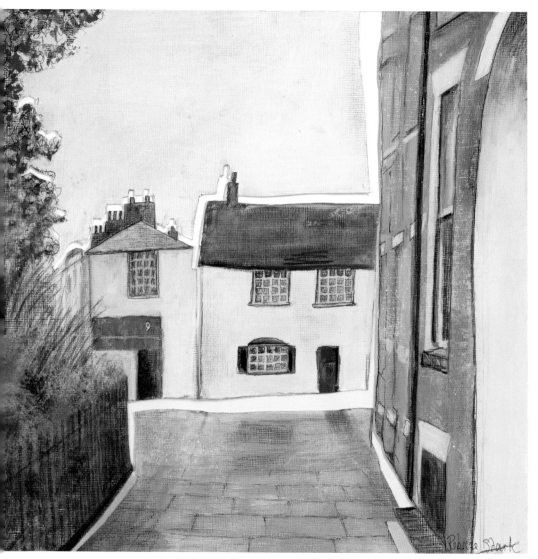

PORTUGAL PLACE, REBECCA STARK

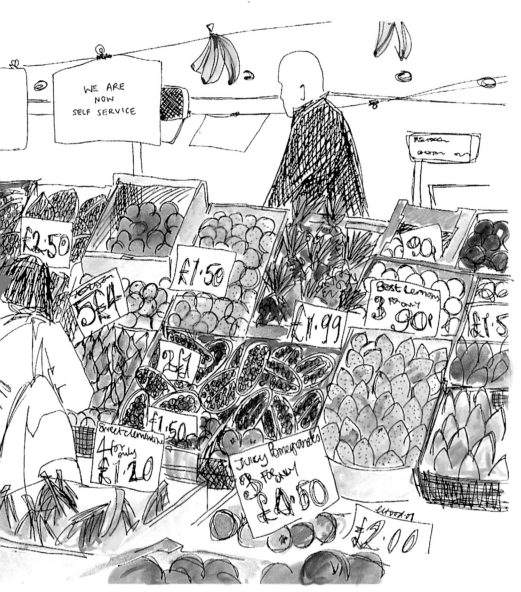

WE ARE
NOW
SELF SERVICE

£2·50

5 £4

£1·50

2 £1

£1·50

£1·99

Best Lemons
3 for any 90p

£1·5

Sweet Clementines
4 for only
£1·20

Juicy Pomegranates
3 for only
£2·50

£2·00

CAMBRIDGE MARKET, AMY HOOD

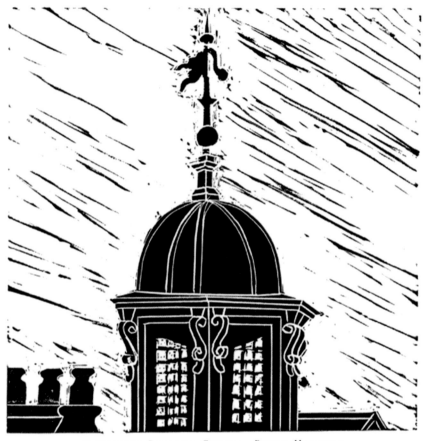

PEMBROKE COLLEGE CHAPEL, PETER HALFORD
OPPOSITE: LOOKING OUT AT CAMBRIDGE, ALEX PREWETT
OVERLEAF: OLD DIVINITY SCHOOL, ST JOHN'S COLLEGE, SAM BOUGHTON

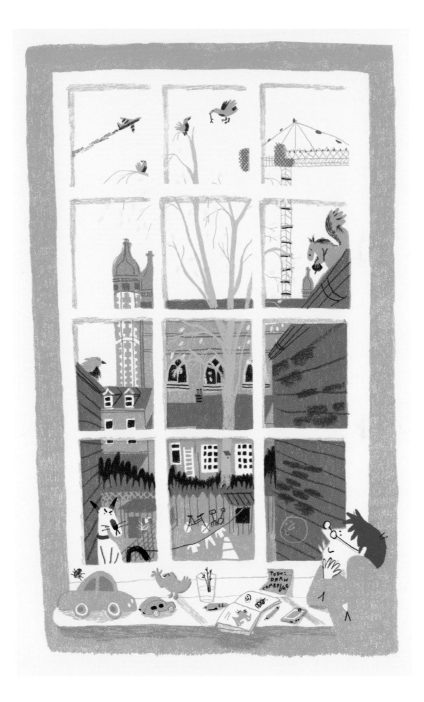

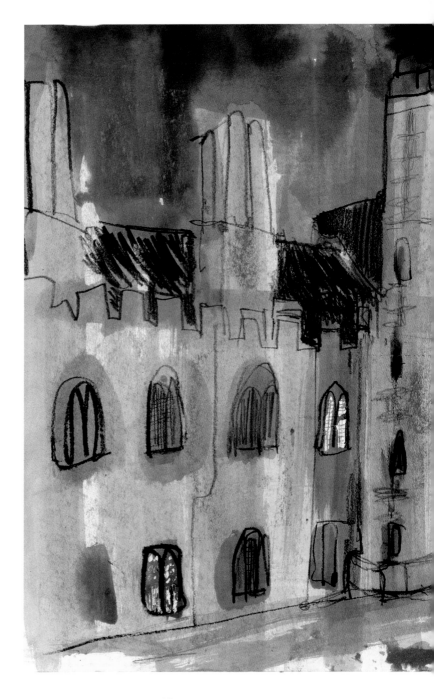

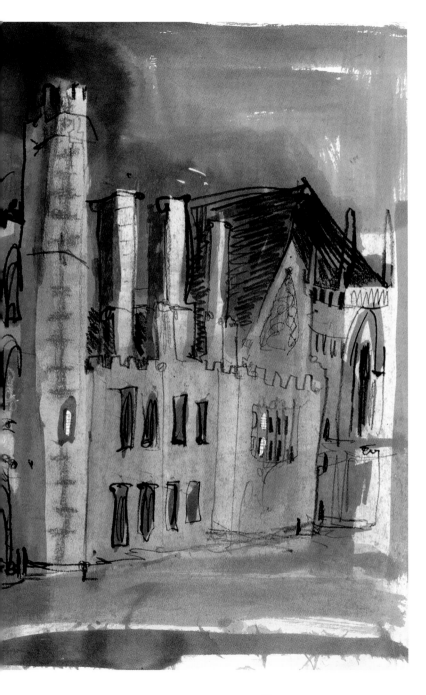

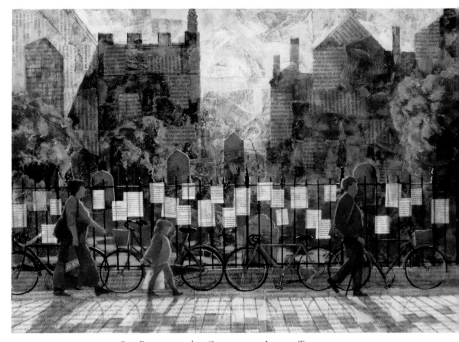

St Botolph's Church, John Tordoff

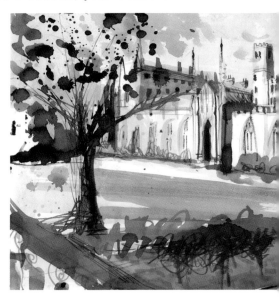

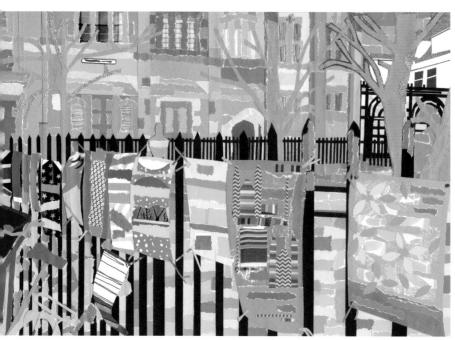

ALL SAINTS' GARDEN, EMMA BENNETT

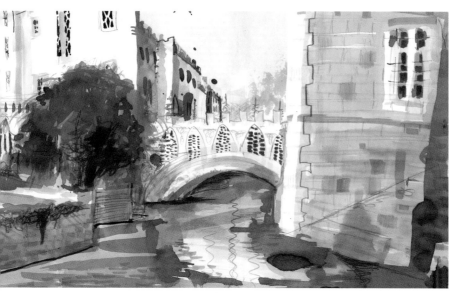

BRIDGE OF SIGHS, ST JOHN'S COLLEGE, SAM BOUGHTON

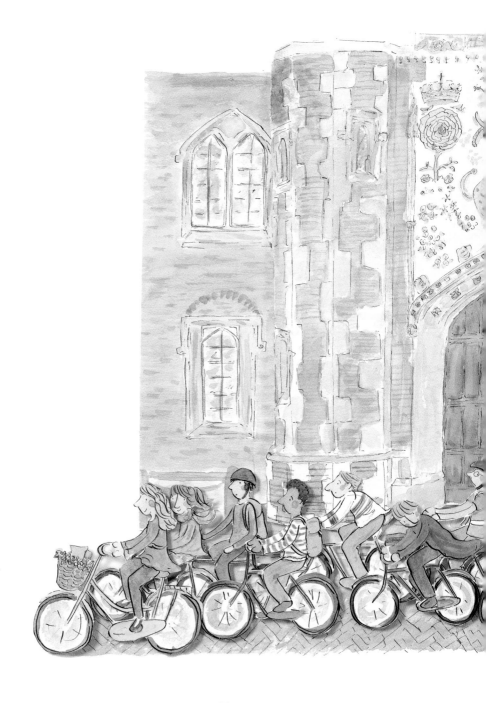

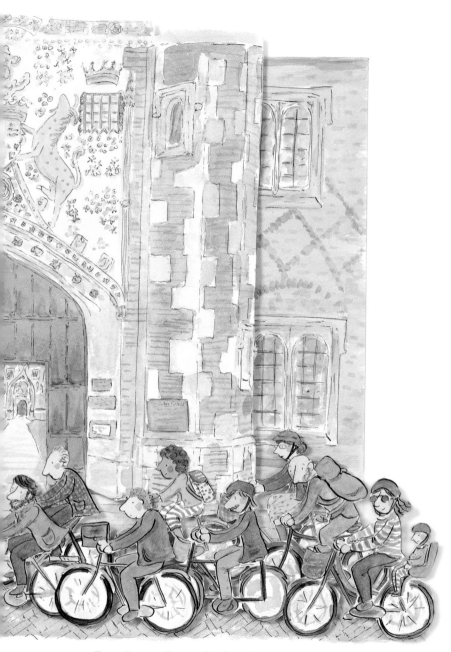

The Great Gate, St John's College, Roxana de Rond

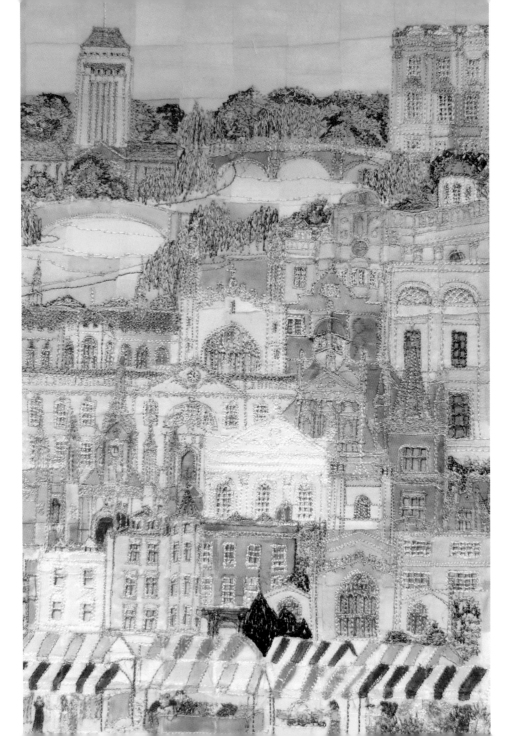

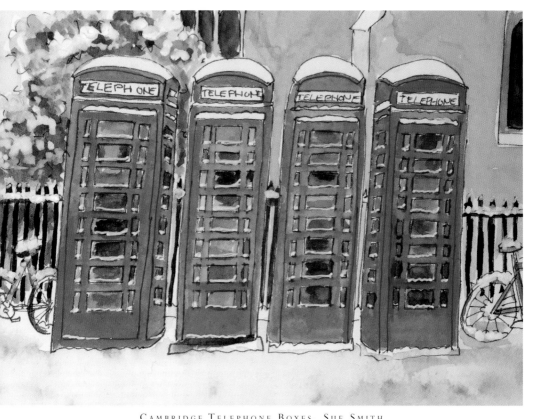

CAMBRIDGE TELEPHONE BOXES, SUE SMITH
OPPOSITE: CAMBRIDGE ROOFTOPS, CLAIRE TURNER

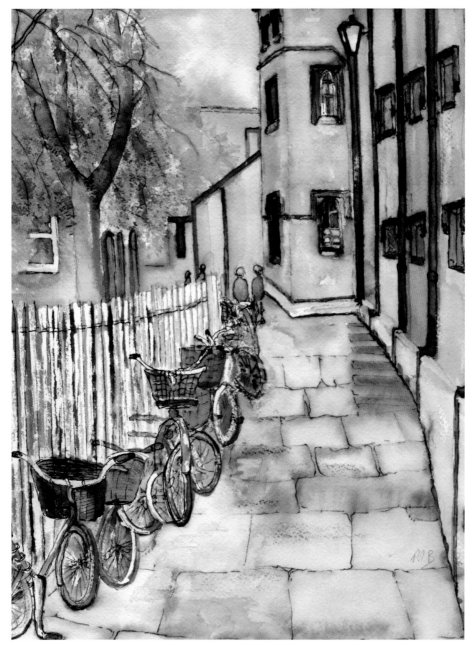

PASSAGEWAY, PAMELA MARSHALL BARRELL

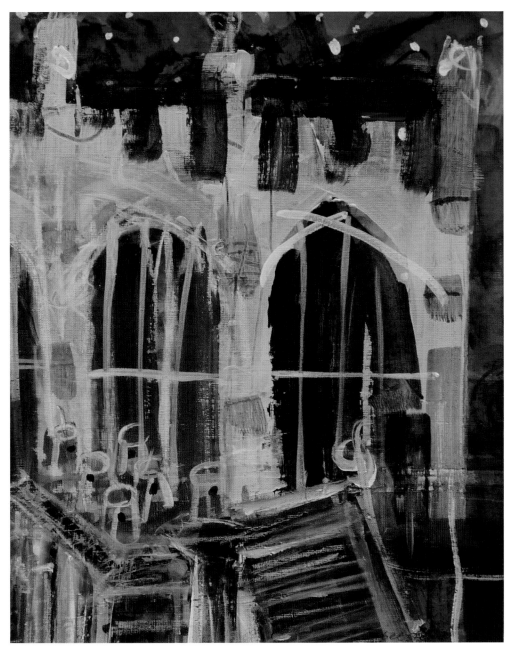

TRINITY COLLEGE CHAPEL, ISOBEL STEMP

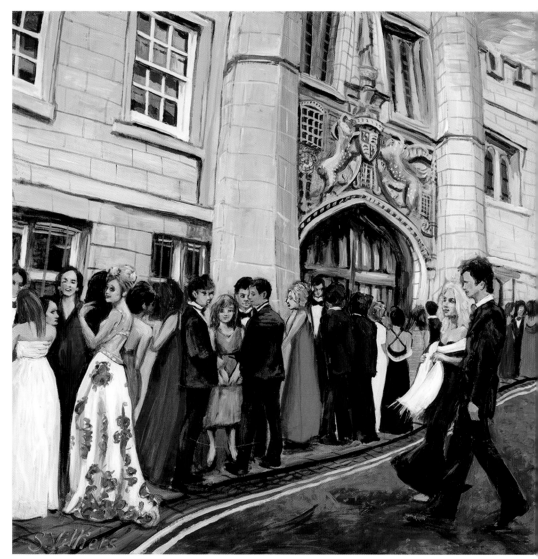

CHRIST'S COLLEGE, SONIA VILLIERS

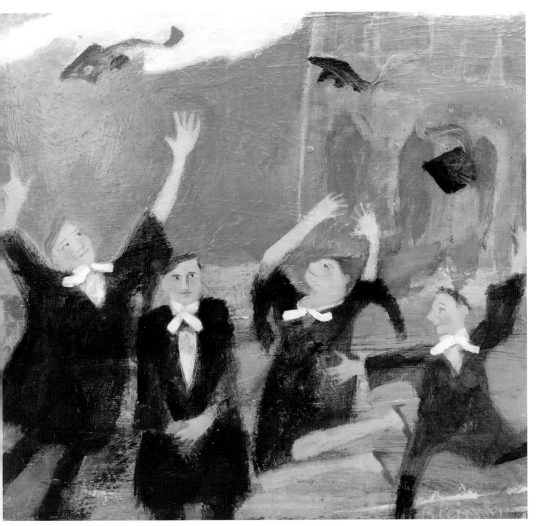

UNIVERSITY GRADUATION, BARBARA PEIRSON

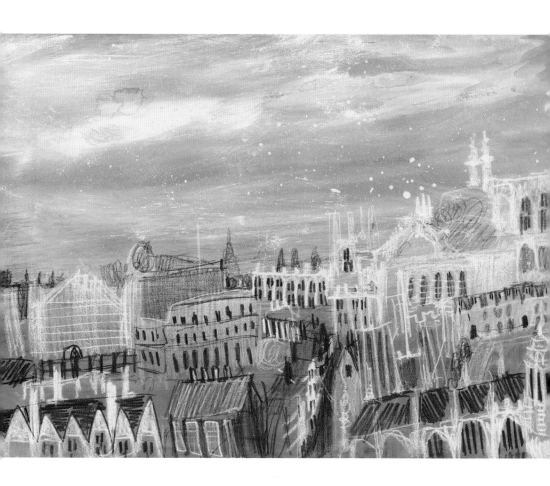

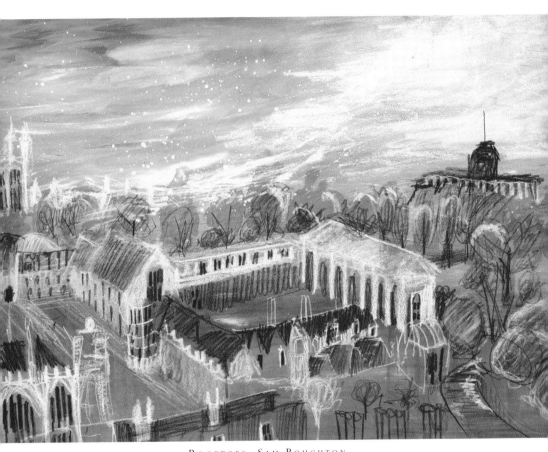

ROOFTOPS, SAM BOUGHTON
OVERLEAF: KING'S COLLEGE AND AROUND, EMMA BENNETT

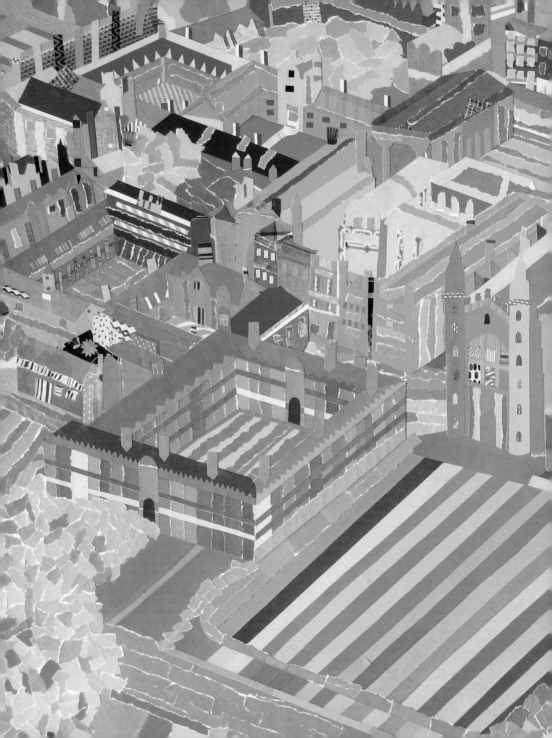

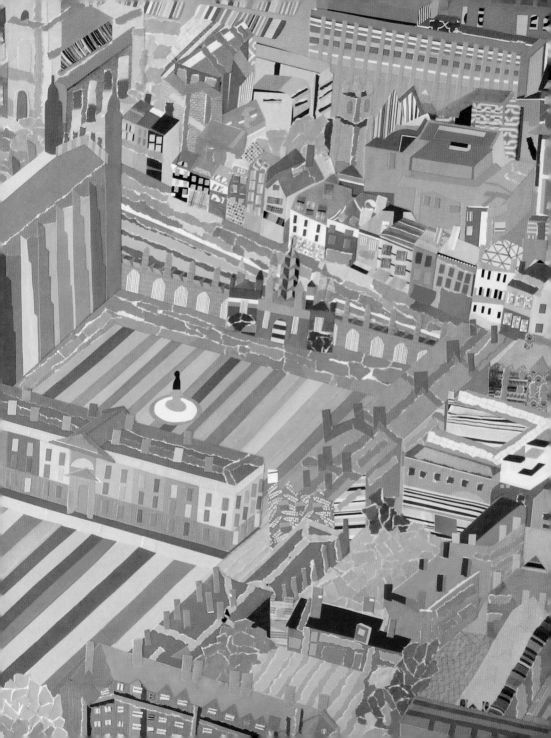

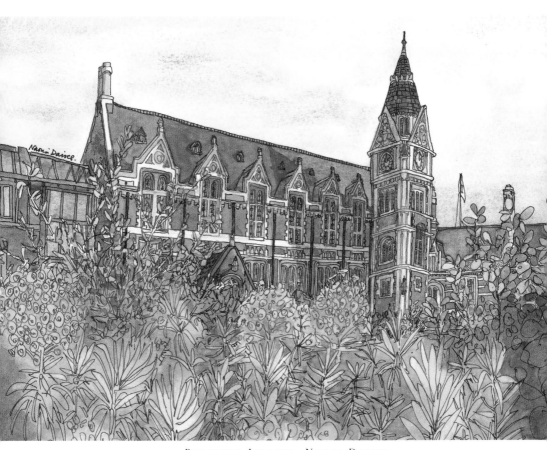

PEMBROKE LIBRARY, NAOMI DAVIES
OPPOSITE: ALL SAINTS' GARDENS, CLAIRE TURNER

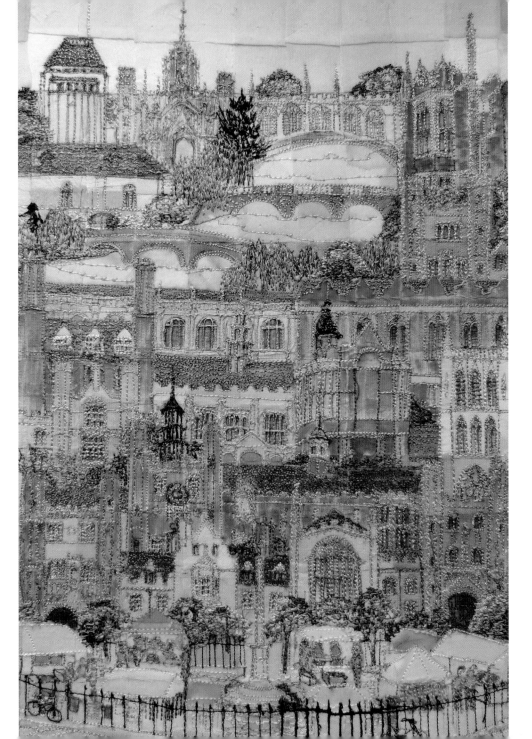

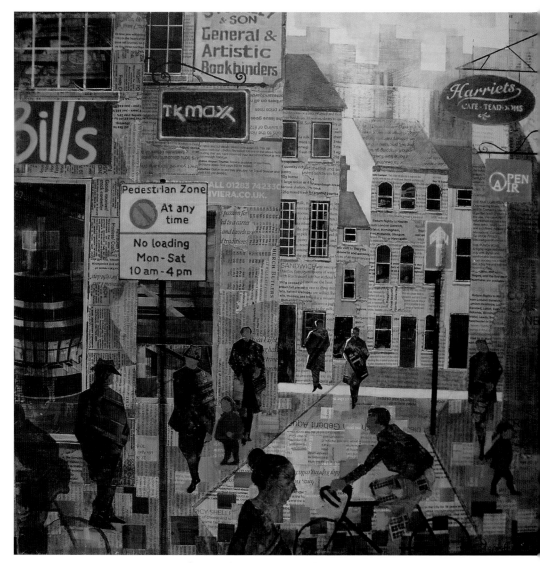

GREEN STREET, JOHN TORDOFF

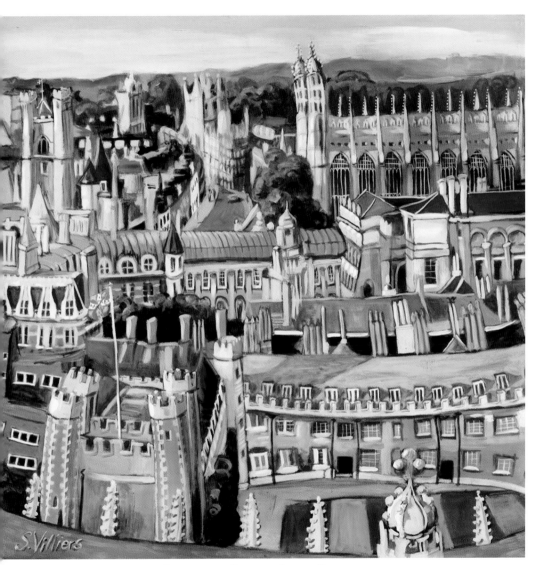

CAMBRIDGE SPIRES, SONIA VILLIERS
OVERLEAF: CORPUS CHRISTI COLLEGE, OPHELIA REDPATH

NO
DOGS

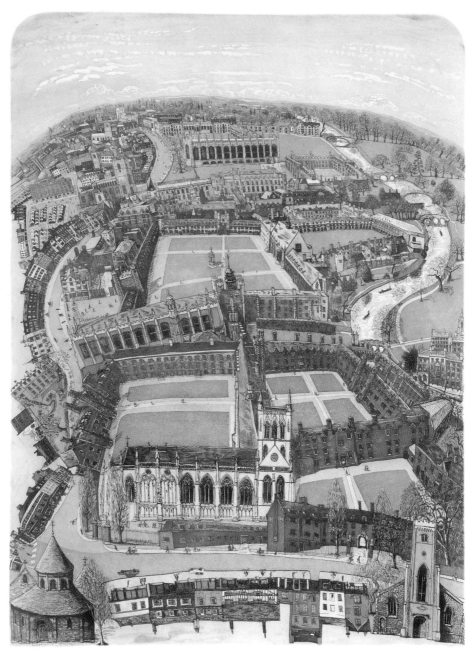

CAMBRIDGE COURTS, GLYNN THOMAS

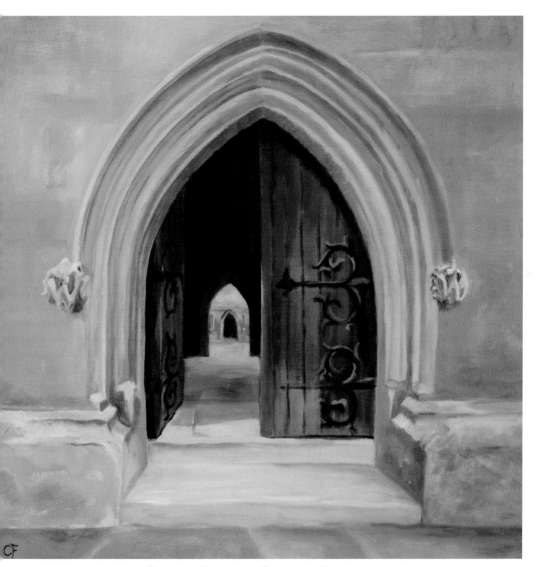

TRINITY COLLEGE, CAROLINE FORWARD
OVERLEAF: TRINITY COLLEGE CHAPEL, ISOBEL STEMP

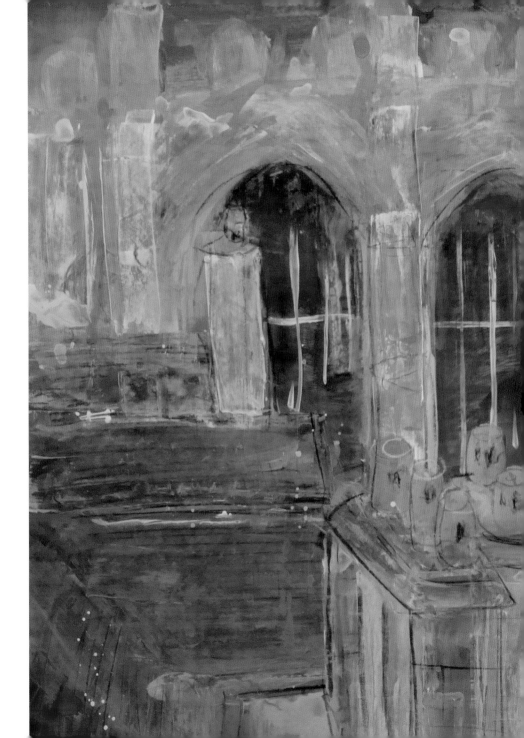

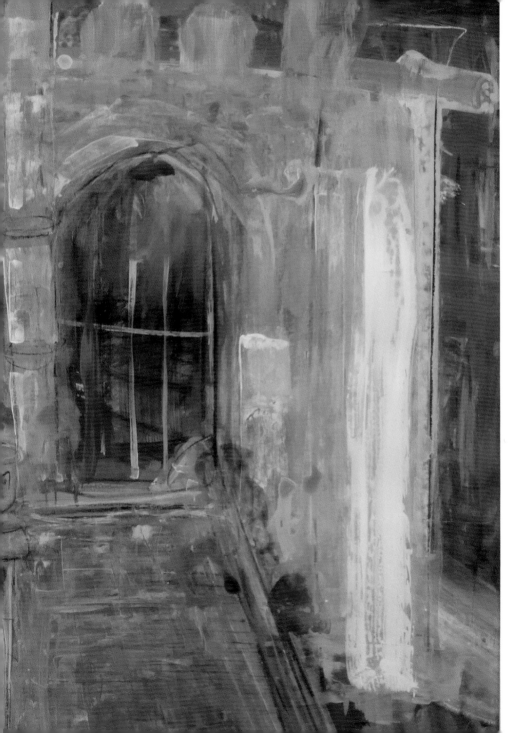

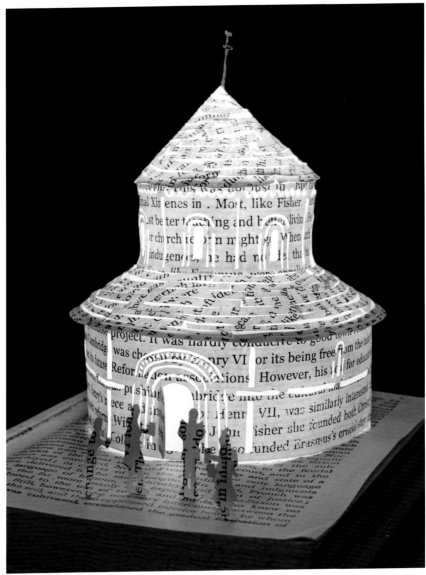

The Round Church (The Church of the Holy Sepulchre), Justin Rowe

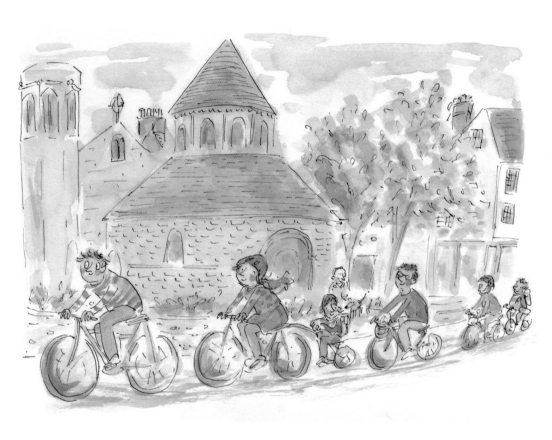

THE ROUND CHURCH, ROXANA DE ROND

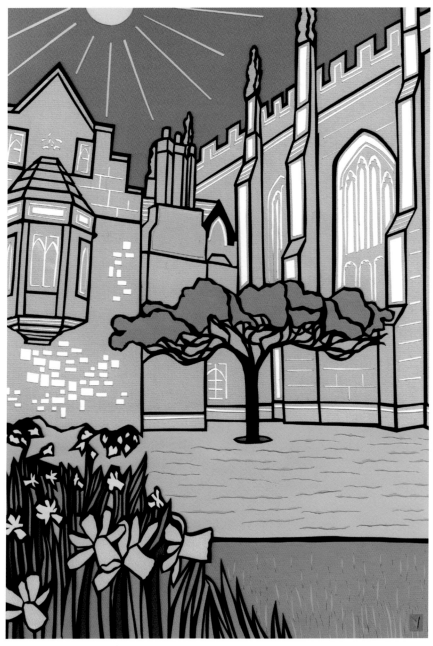

NEWTON'S TREE, TRINITY COLLEGE, VANESSA STONE

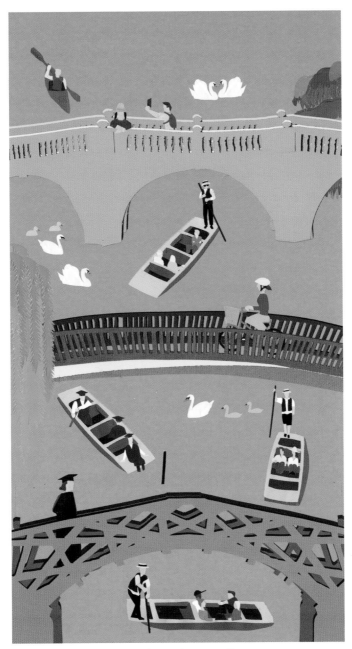

THE RIVER CAM, JEREMY HOGARTH

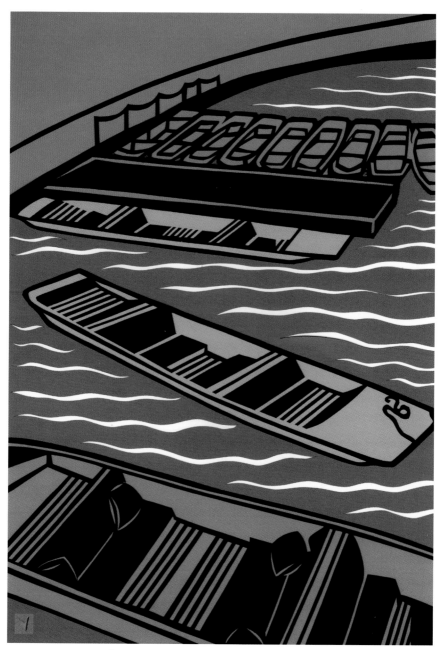

PUNTS ON THE RIVER, VANESSA STONE

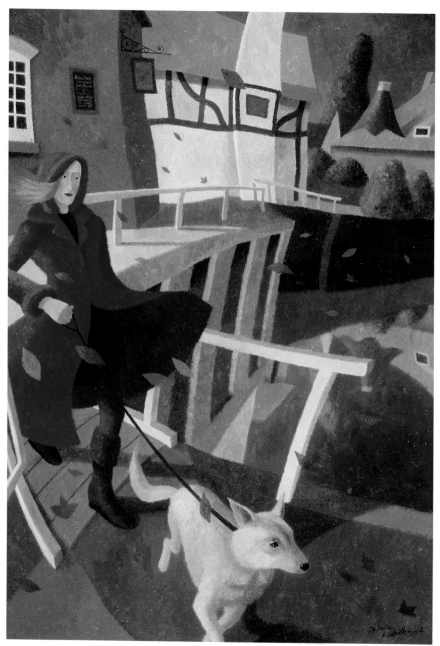

THE MILL POND, OPHELIA REDPATH

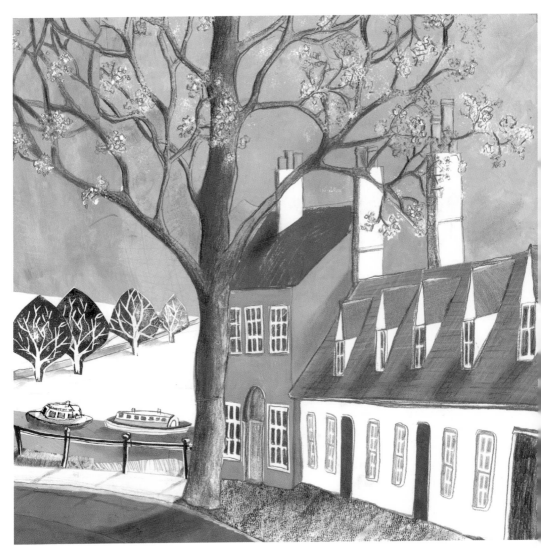

CHESTERTON LANE, REBECCA STARK

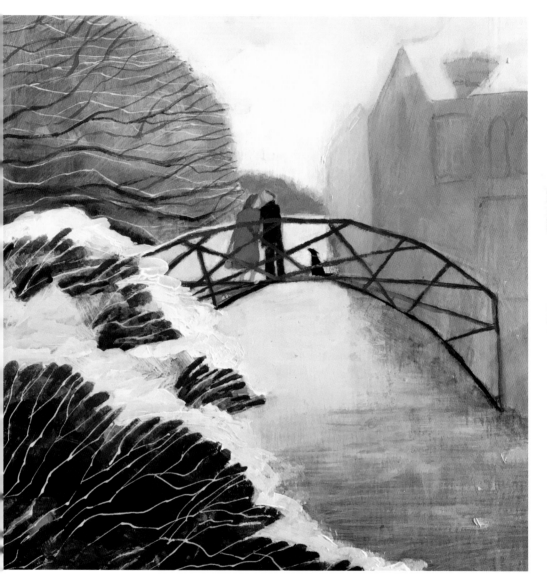

THE RIVER CAM, BARBARA PEIRSON

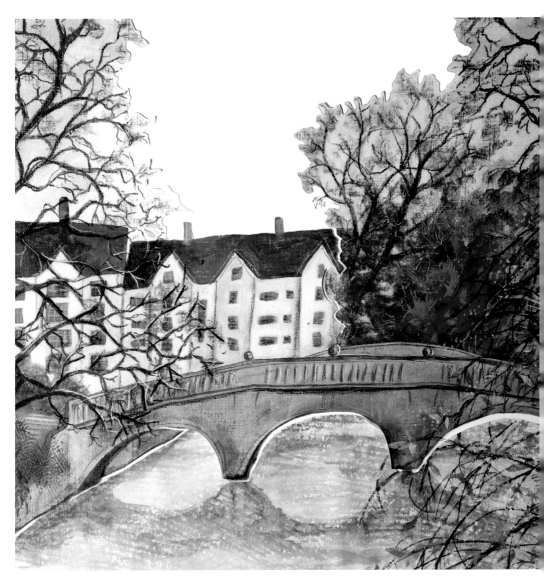

CLARE BRIDGE, REBECCA STARK

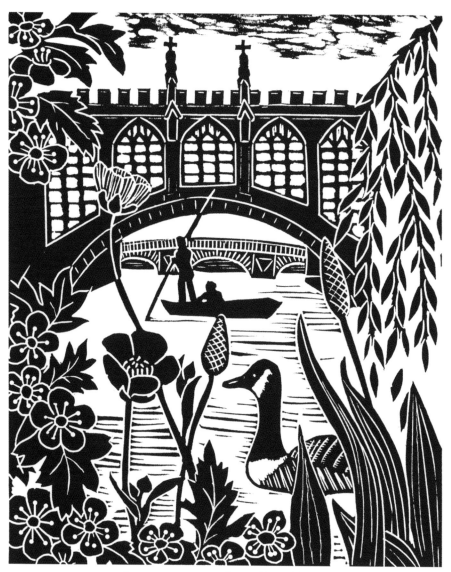

PUNTING ON THE CAM, KATE HEISS
OVERLEAF: BRIDGE OF SIGHS, LYNSEY HUNTER

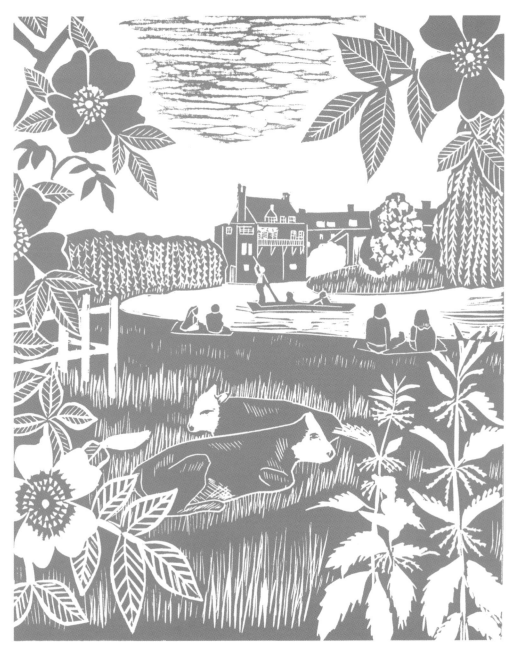

THE MILL POND, KATE HEISS

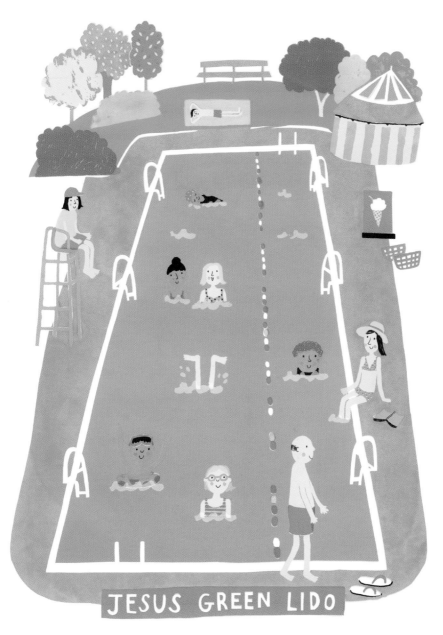

JESUS GREEN LIDO, JENNY SEDDON

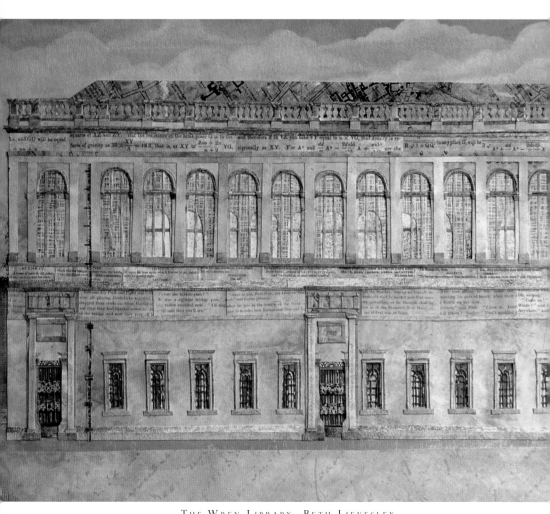

THE WREN LIBRARY, BETH LIEVESLEY

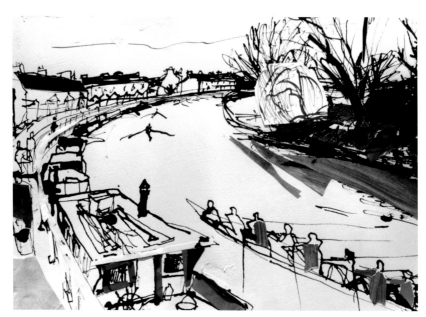

ROWERS ON THE RIVER, SAM MOTHERWELL

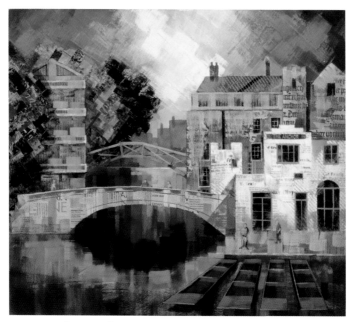

SILVER STREET BRIDGE, JOHN TORDOFF

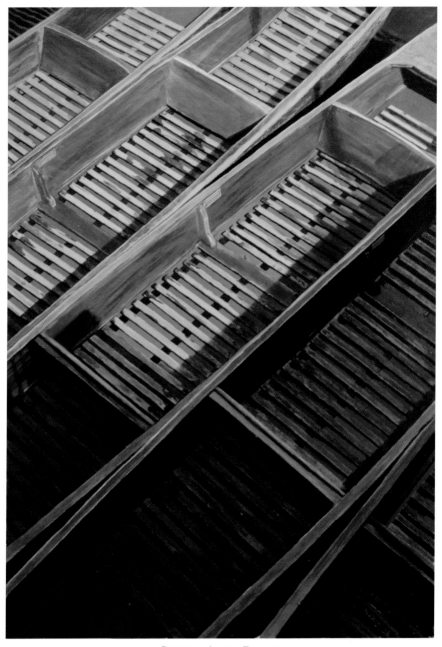

PUNTS, ANDY DAKIN

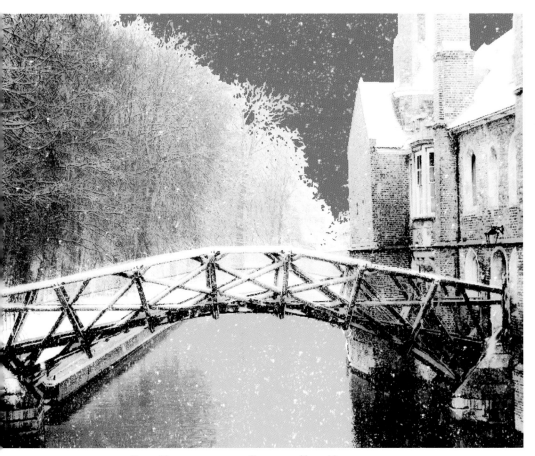

THE MATHEMATICAL BRIDGE, TIM MIDDLETON

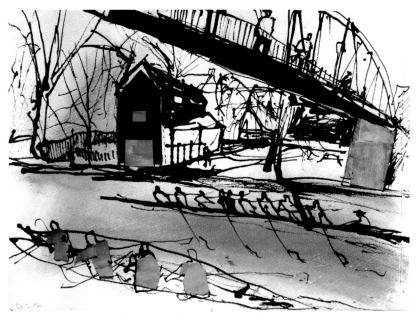

GREEN DRAGON BRIDGE, SAM MOTHERWELL

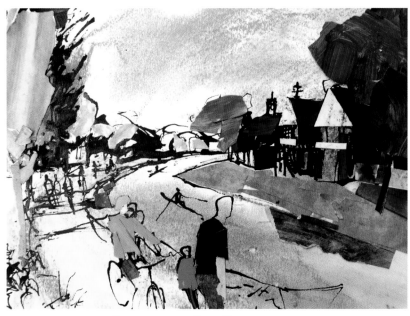

BOATHOUSES, SAM MOTHERWELL

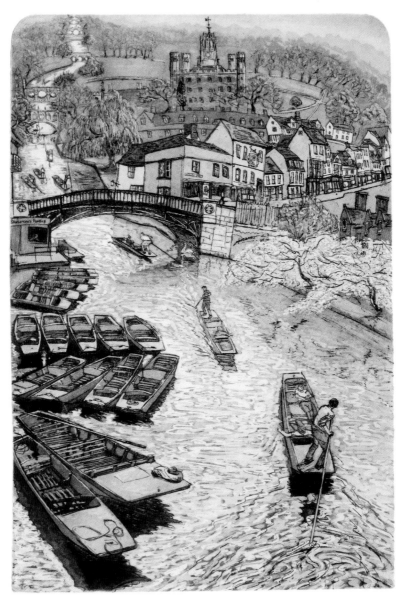

The River Cam, Glynn Thomas

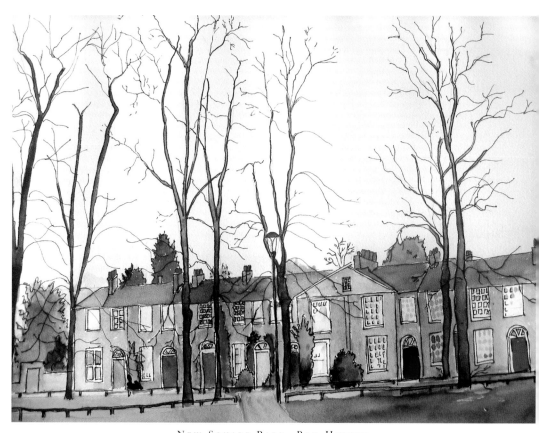

NEW SQUARE PARK, PAM HINTON

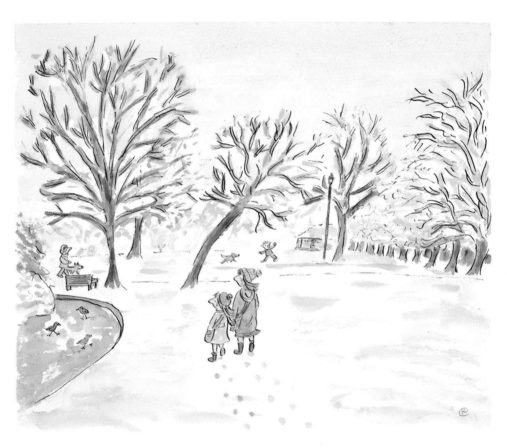

JESUS GREEN, ROXANA DE ROND

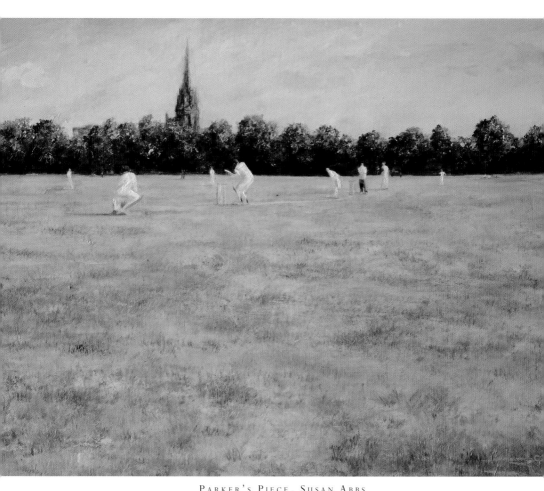

PARKER'S PIECE, SUSAN ABBS

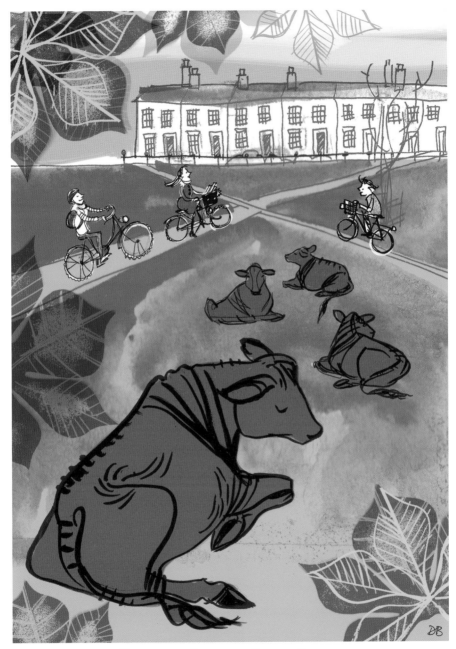

MIDSUMMER COMMON, DEBBIE BELLABY

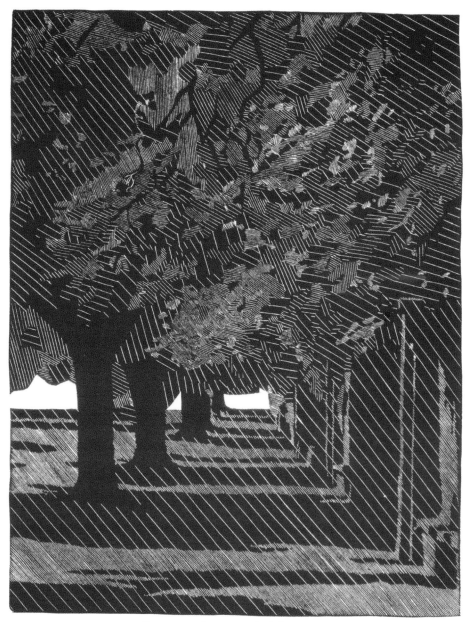

VICTORIA AVENUE, A J BLUSTIN

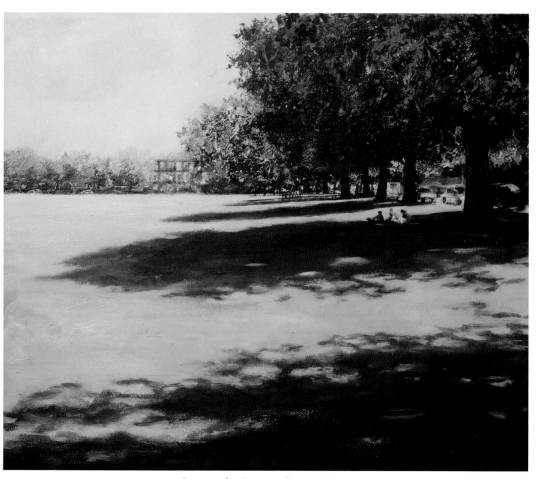

PARKER'S PIECE, SUSAN ABBS
OVERLEAF: TREE OF CAMBRIDGE, MAUREEN MACE

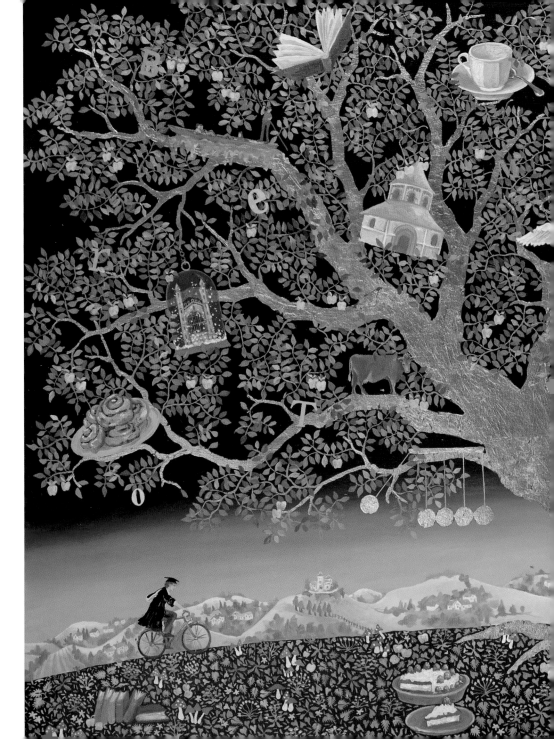

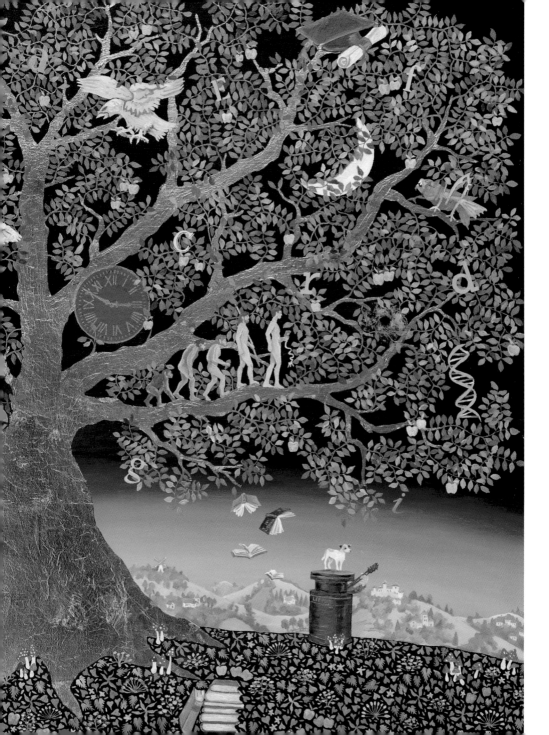

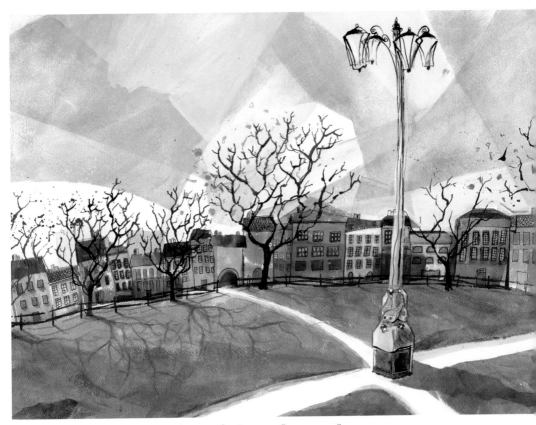

PARKER'S PIECE, REBECCA STARK

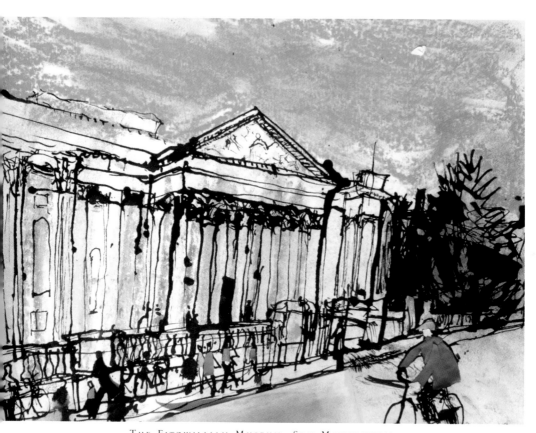

THE FITZWILLIAM MUSEUM, SAM MOTHERWELL

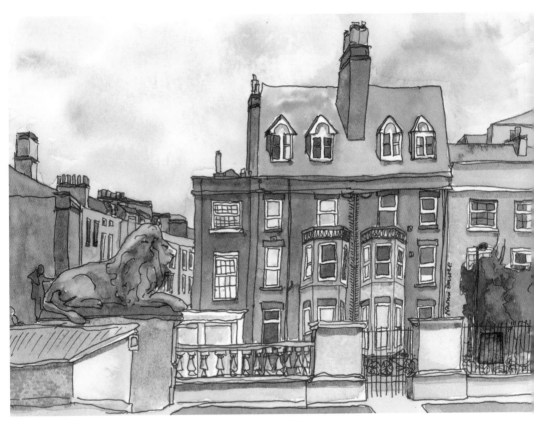

VIEW FROM THE FITZWILLIAM MUSEUM, NAOMI DAVIES

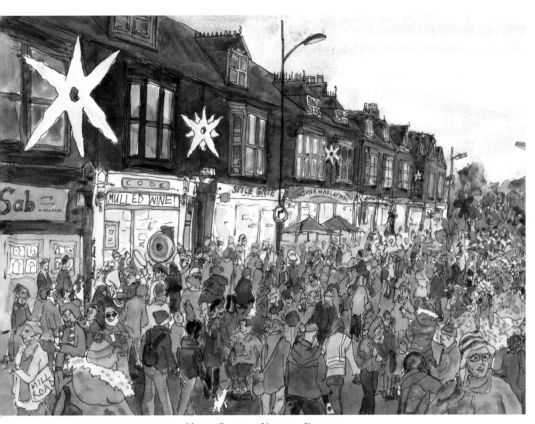

MILL ROAD, NAOMI DAVIES

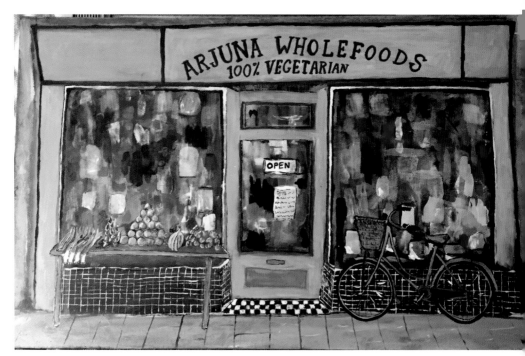

MILL ROAD, COLIN WILES

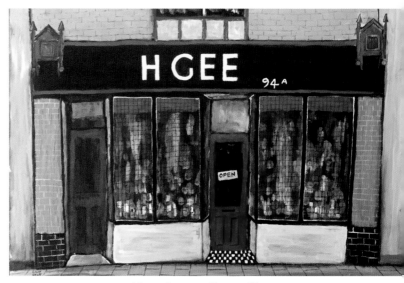

MILL ROAD, COLIN WILES

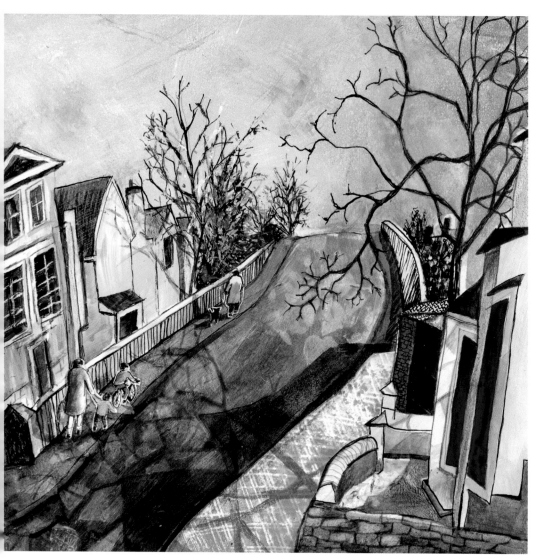

MILL ROAD BRIDGE, REBECCA STARK

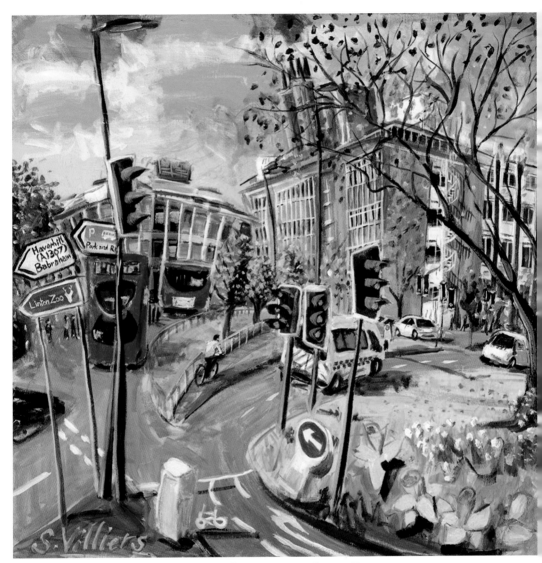

ADDENBROOKE'S HOSPITAL, SONIA VILLIERS

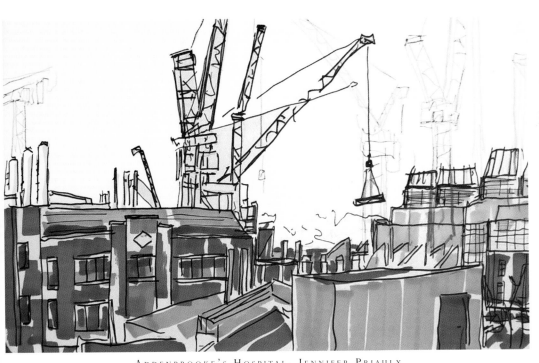

ADDENBROOKE'S HOSPITAL, JENNIFER PRIAULX

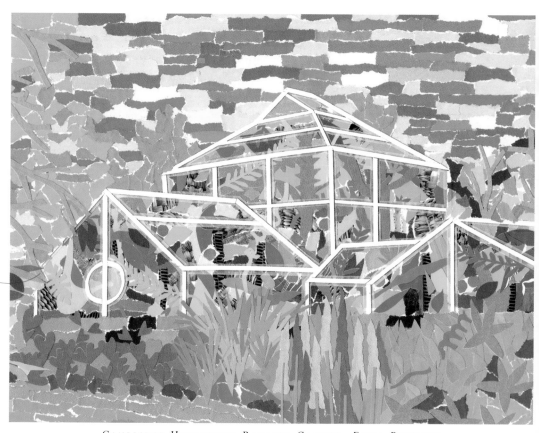

CAMBRIDGE UNIVERSITY BOTANIC GARDEN, EMMA BENNETT

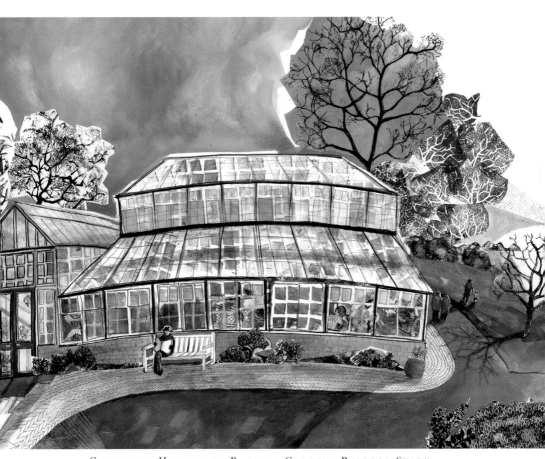

CAMBRIDGE UNIVERSITY BOTANIC GARDEN, REBECCA STARK

CAMBRIDGE RAILWAY STATION, ANNA BROWN

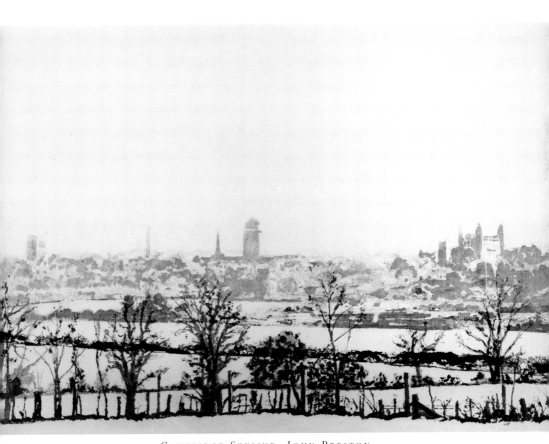

CAMBRIDGE SKYLINE, JOHN PRESTON

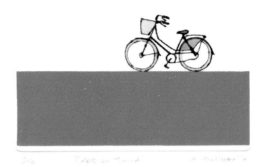

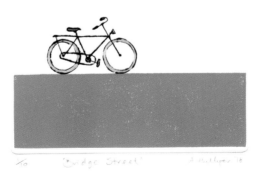

CAMBRIDGE ILLUSTRATIONS, ALISON HULLYER
OPPOSITE: CAMBRIDGE ILLUSTRATIONS, EMILY KIDDY

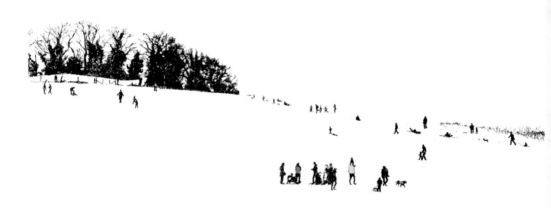

THE GOG MAGOG DOWNS, JOHN PRESTON

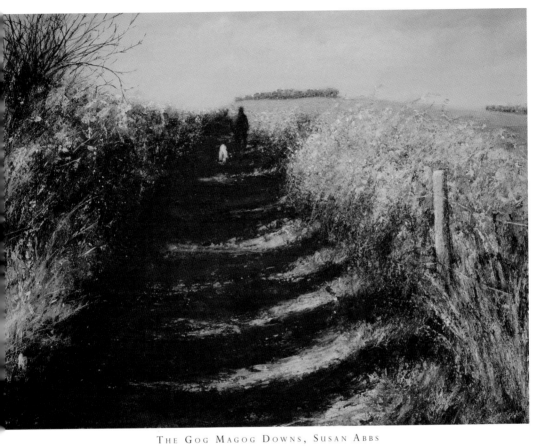

THE GOG MAGOG DOWNS, SUSAN ABBS

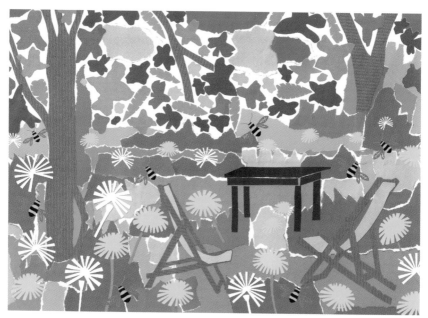

THE ORCHARD, GRANTCHESTER, EMMA BENNETT

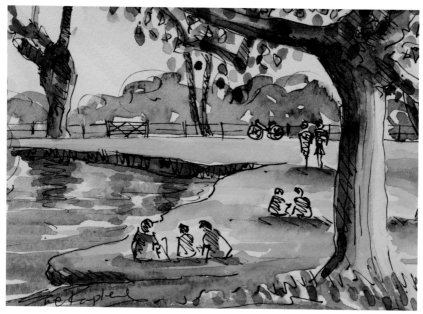

GRANTCHESTER, SUE RAPLEY

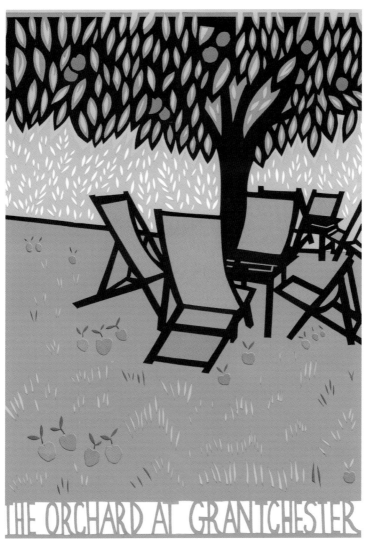

THE ORCHARD, GRANTCHESTER, VANESSA STONE

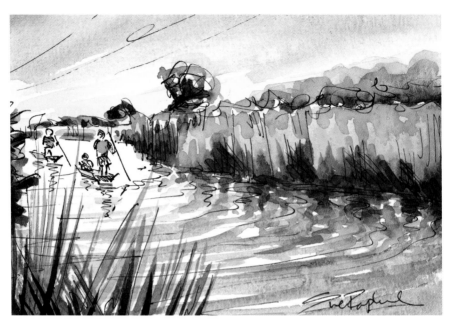

GRANTCHESTER, SUE RAPLEY

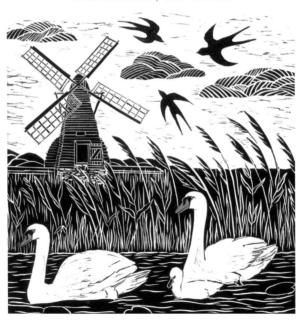

WICKEN FEN, ANNA PYE

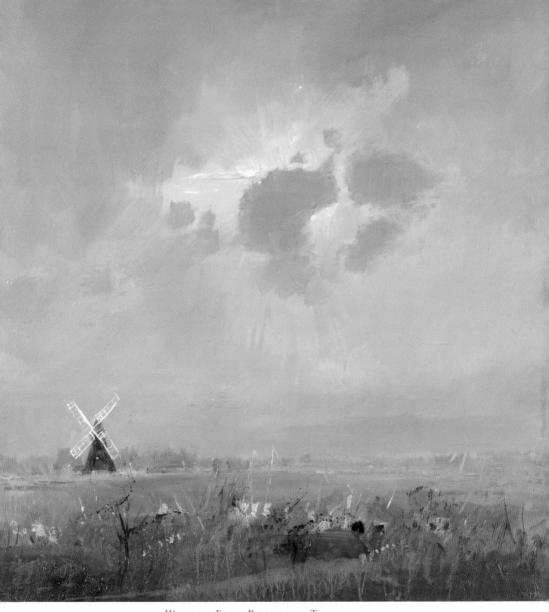

WICKEN FEN, ROSEMARY TRESTINI

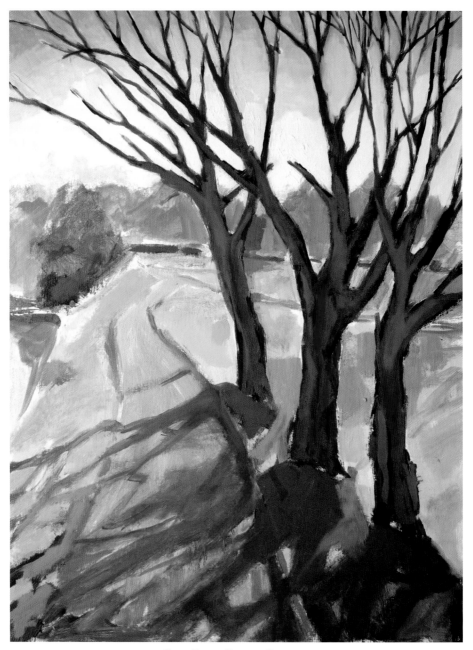

COE FEN, CATHY PARKER

116

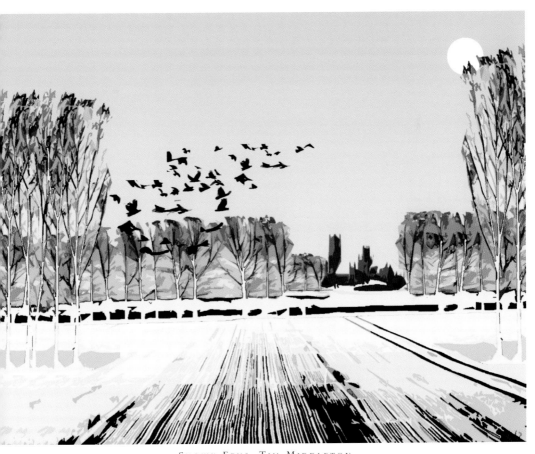

SNOWY FENS, TIM MIDDLETON

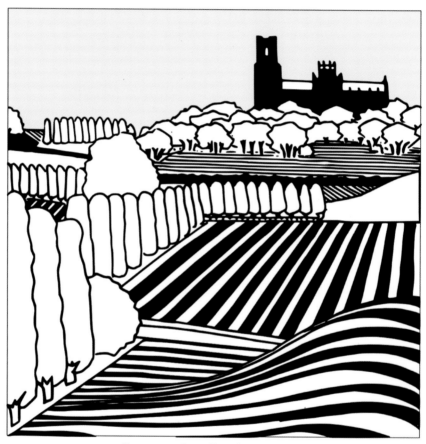

Towards Ely, Tim Middleton

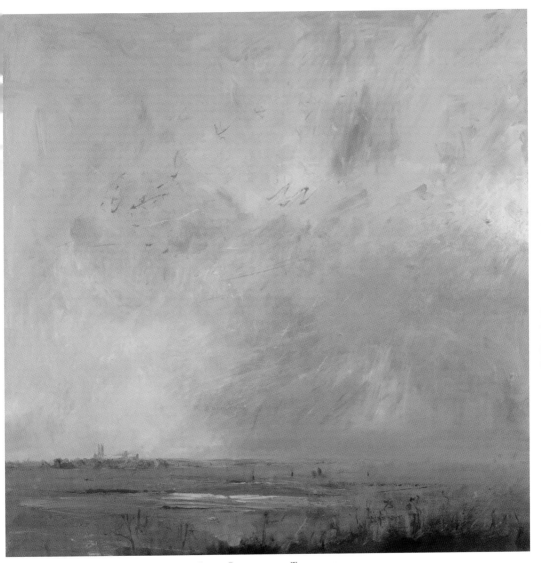

ELY, ROSEMARY TRESTINI

119

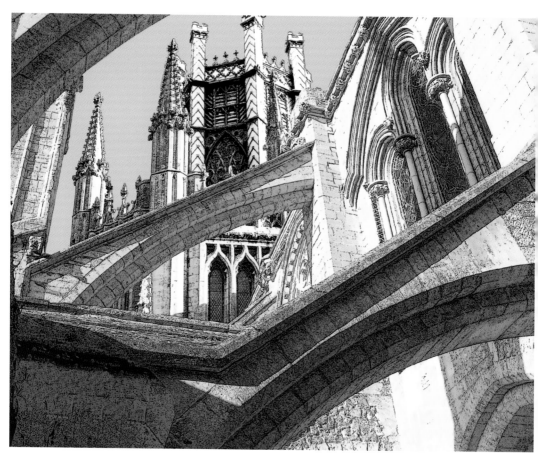

ELY CATHEDRAL, TIM MIDDLETON

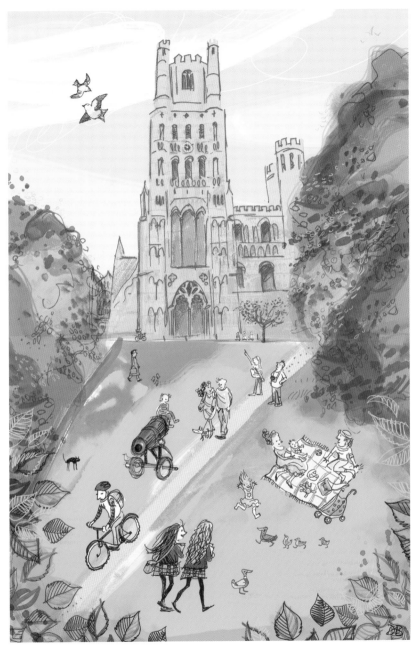

Ely Cathedral, Debbie Bellaby

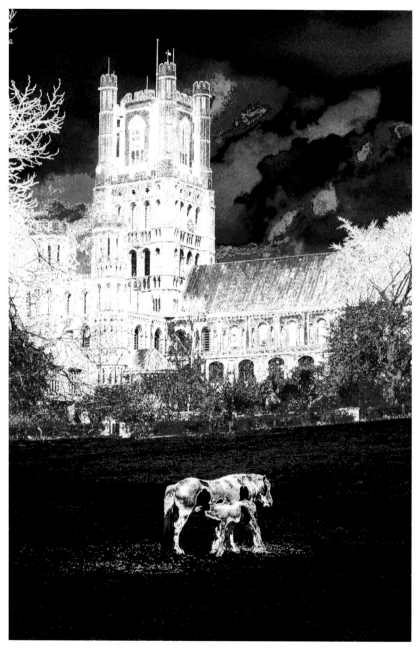

ELY CATHEDRAL, MALCOLM LANE

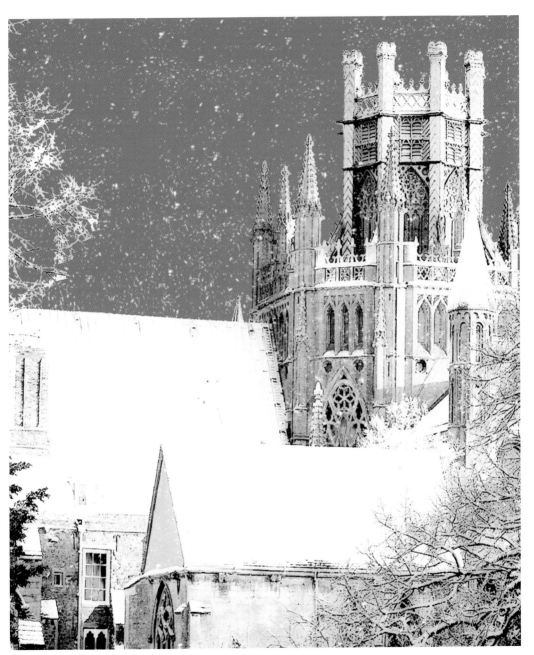

ELY CATHEDRAL, TIM MIDDLETON

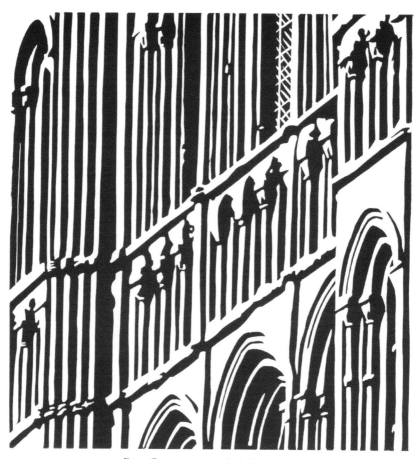

ELY CATHEDRAL, A J BLUSTIN
OPPOSITE: ELY CATHEDRAL, EMMA BENNETT

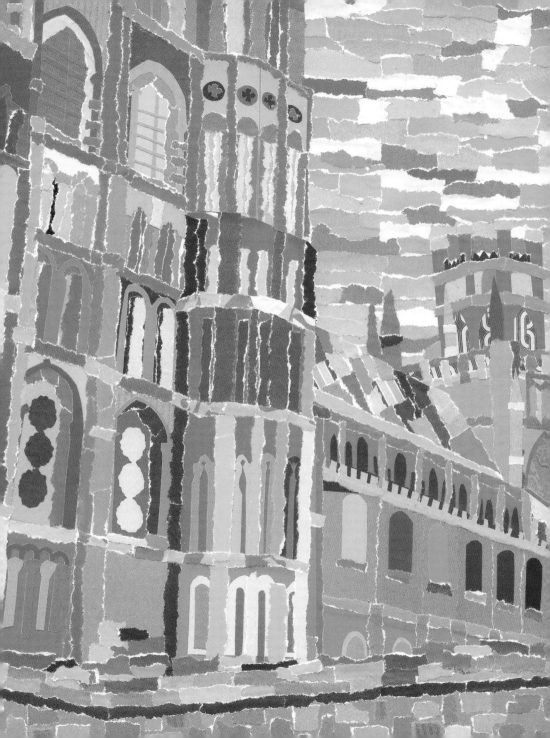

ARTISTS' CREDITS

Abbs, Susan
© Susan Abbs
Contemporary mixed media paintings.
www.susanabbs.co.uk
All rights reserved.
Pages 90, 93, 111

Barrell, Pamela Marshall
© Pamela Marshall Barrell
Bicycles, alleyways, buildings & leaves in mixed media.
www.artsviews.co.uk
All rights reserved.
Page 50

Bellaby, Debbie
© Debbie Bellaby Illustration
Illustrating in mixed media. Drawing is at the heart of all her work.
www.debbiebellaby.com
All rights reserved.
Pages 91, 121

Bennett, Emma
© Emma Bennett Collage
Vibrant hand-cut collage using only papers recycled from magazines.
www.emmabennettcollage.co.uk
All rights reserved.
Cover and pages 45, 56, 104, 112, 125

Blustin, A J
© A J Blustin
Linocuts: forms, structures, patterns, connections, light & shade.
local-artists.org/users/aj-blustin
All rights reserved.
Pages 92, 124

Boughton, Sam
© Sam Boughton
Landscape and reportage illustrations created on location using inks, watercolour and pastel pencils.
www.samboughton.co.uk
All rights reserved.
Pages 23, 42, 45, 54

Brown, Anna
© Anna Brown
Illustrations & prints featuring mostly rabbits, polar bears & assorted woodland creatures.
www.rabbitswhiskers.co.uk
All rights reserved.
Page 106

Caulfield, Clare
© Clare Caulfield
City inspired mixed-media paintings & prints in a lively drawing style.
www.clarecaulfield.co.uk
All rights reserved.
Pages 16, 22

Dakin, Andy
© Andy Dakin
Images from real life in oil & charcoal.
www.andydakinartist.com
All rights reserved.
Pages 18, 20, 84

Davies, Naomi
© Naomi Davies Art
Pen drawings often with watercolour. Loves bikes. Urban sketcher.
www.naomidaviesart.co.uk
All rights reserved.
Pages 26, 58, 98, 99

de Rond, Roxana
© Roxana de Rond
Illustrations in ink & gouache featuring the humorous & the everyday.
www.roxanaillustrations.co.uk
All rights reserved.
Pages 46, 69, 89

Forward, Caroline
© Caroline Forward
Oil paintings in a range of subjects including portraits, places & abstracts.
www.carolineforward.co.uk
All rights reserved.
Page 65

Halford, Peter
© Peter Halford
Architecture & landscape graphic art & photography.
peter@peterhalford.co.uk
All rights reserved.
Page 40

Heiss, Kate
© Kate Heiss
Contemporary Printmaker & Designer creating limited edition screen prints & linocuts.
www.kateheiss.com
All rights reserved.
Pages 77, 80

Hinton, Pam
© Pam Hinton
Painter in a variety of mediums. Mainly architectural & floral subjects.
pamhintonuk@yahoo.co.uk
All rights reserved.
Page 88

Hogarth, Jeremy
© Jeremy Hogarth
Paper-cut collage illustration.
www.jeremyhogarthillustration.com
All rights reserved.
Page 71

Hood, Amy
© Amy Hood
Pen & watercolour on paper.
https://www.amyhoodillustration.co.uk
All rights reserved.
Page 38

Hullyer, Alison
© Alison Hullyer
Professional printmaker, illustrator & designer specialising in drypoint & relief prints.
www.hullyer.co.uk
All rights reserved.
Page 109

Hunter, Lynsey
© Lynsey Hunter
Mixed media illustration & textiles.
www.lynsey-hunter.co.uk
All rights reserved.
Page 78

Kiddy, Emily
© Emily Kiddy
Cambridge based fashion designer with a passion for graphical print & illustration.
www.emilykiddy.blogspot.co.uk
All rights reserved.
Page 108

King, Alison
© Alison King
Oils, cold-wax techniques, & printmaking, inspired by local scenes & big skies.
http://www.alisonking.co.uk
All rights reserved.
Page 10

Lane, Malcolm
© Malcolm Lane
Digital images, drawings & acrylic paintings of a variety of subjects.
www.malcolmlaneimages.com
All rights reserved.
Page 122

Lievesley, Beth
© Beth Lievesley
Hand-cut collage using mix of old books, maps, vintage & patterned papers.
www.mayqueendesigns.co.uk
All rights reserved.
Page 82

Lindsay, Marion
© Marion Lindsay
Children's illustration using ink & collage.
www.marionlindsay.co.uk
All rights reserved.
Page 25

Mace, Maureen
© Maureen Mace
Colourful, intricate, dreamlike
paintings of trees, people &
Cambridge.
www.maureenmace.co.uk
All rights reserved.
Pages 14, 94

Margiotta, Paul
© Paul Margiotta
Hand-drawn & digital illustrations
& designs in a range of media.
www.piljam.com
All Rights Reserved.
Pages 31, 33

Masko, Iryna
© Iryna Masko
Digital art & photography.
http://www.irynamasko.co.uk
All rights reserved.
Page 27

Middleton, Tim
© Tim Middleton
Digitally enhanced photo montage.
www.tmprints.co.uk
All rights reserved.
Pages 85, 117, 118, 120, 123

Motherwell, Sam
© Sam Motherwell
Pen, ink, pastel & collage.
sammotherwell.weebly.com
All rights reserved.
Pages 83, 86, 97

Parker, Cathy
© Cathy Parker
Trees & landscapes, various
media, painted outdoors or semi-
abstracted in the studio.
www.cathyparker.co.uk
All rights reserved.
Page 116

Peirson, Barbara
© Barbara Peirson
A background in theatre influences
an evocative artistic description of
everyday life.
www.barbarapeirson.com
All rights reserved.
Pages 9, 53, 75

Phillips, Clare
© Clare Phillips
Digitally illustrated giclee fine
art print.
www.clarephillips.com
All rights reserved.
Page 30

Preston, John
© John Preston
Atmospheric etchings & paintings,
mostly of buildings & landscapes.
jpreston@phonecoop.coop
All rights reserved.
Pages 24, 107, 110

Prewett, Alex
© Alex Prewett
Freelance Illustrator
www.alexprewett.co.uk
All rights reserved.
Page 41

Priaulx, Jennifer
© Jennifer Priaulx
Painter & print-maker.
www.jenniferpriaulx.co.uk
All rights reserved.
Page 103

Pye, Anna
© Anna Pye
Original lino cuts, screen prints &
mono prints.
www.annapye.com
All rights reserved.
Page 114

Rapley, Sue
© Sue Rapley
Vibrant & expressive sea & land-
scape paintings in a range of media.
www.suerapley.co.uk
All rights reserved.
Pages 112, 114

Redpath, Ophelia
© Ophelia Redpath
Surreal, colourful oil paintings, pen
& ink graphic posters & illustrated
books.
www.opheliaredpath.uk
All rights reserved.
Pages 29, 62, 73

Rowe, Justin
© Justin Rowe
Paper sculpture hand-cut from
vintage books.
www.daysfalllikeleaves.com
All rights reserved.
Page 68

Seddon, Jenny
© Jenny Seddon
Handmade, limited edition screen
prints.
www.jennyseddon.com
All rights reserved.
Page 81, map of Cambridge and
endpapers

Smith, Sue
© Sue Smith
Pen & watercolour scenes of
Cambridge. Other media.
www.suesmithart.com
All rights reserved.
Pages 36, 49

Stark, Rebecca
© Rebecca Stark
Mixed media collage.
www.rebeccastark.co.uk
All rights reserved.
Pages 34, 70, 74, 76, 96, 101, 105

Stemp, Isobel
© Isobel Stemp
Painter in acrylic & gouache.
www.isobelstemp.co.uk
All rights reserved.
Pages 8, 51, 66

Stone, Vanessa
© Vanessa Stone
Hand cut reverse layered collages
inspired by English towns &
countryside.
www.vanessastoneartist.com
All rights reserved.
Pages 70, 72, 113

Thomas, Glynn
© Glynn Thomas
Member of Royal Society Painter-
Printmakers, specialising in etching
& illustration.
www.studio@glynnthomas.com
All rights reserved.
Pages 64, 87

Tordoff, John
© John Tordoff
Former actor, resident in
Cambridge from 2009. Works
mainly in mixed media.
www.john-tordoff.co.uk
All rights reserved.
Pages 15, 44, 60, 83

Trestini, Rosemary
© Rosemary Trestini
Oil paintings on canvas in a range
of subjects.
www.rosemarytrestini.com
All rights reserved.
Pages 12, 23, 115, 119

Tunmer, Jo
© Jo Tunmer
Visual artist specialising in
solarplate etching & oil painting.
www.jotunmer.com
All rights reserved.
Page 32

Turner, Claire
© Claire Turner
Drawn & stitched images on silk.
www.claireturner-art.com
All rights reserved.
Pages 48, 59

Villiers, Sonia
© Sonia Villiers
Funky views of familiar scenes in
acrylic & alkyd colours.
www.soniavilliers.net
All rights reserved.
Pages 13, 19, 28, 52, 61, 102

Wiles, Colin
© Colin Wiles
Painter in oils, on board or canvas.
https://colinwilespaintings.
wordpress.com/paintings/
All rights reserved.
Page 100

ARTISTS

Abbs, Susan 90, 93, 111

Barrell, Pamela Marshall 50

Bellaby, Debbie 91, 121

Bennett, Emma 45, 56, 104, 112, 125

Blustin, A J 92, 124

Boughton, Sam 23, 42, 45, 54

Brown, Anna 106

Caulfield, Clare 16, 22

Dakin, Andy 18, 20, 84

Davies, Naomi 26, 58, 98, 99

de Rond, Roxana 46, 69, 89

Forward, Caroline 65

Halford, Peter 40

Heiss, Kate 77, 80

Hinton, Pam 88

Hogarth, Jeremy 71

Hood, Amy 38

Hullyer, Alison 109

Hunter, Lynsey 78

Kiddy, Emily 108

King, Alison 10

Lane, Malcolm 122

Lievesley, Beth 82

Lindsay, Marion 25

Mace, Maureen 14, 94

Margiotta, Paul 31, 33

Masko, Iryna 27

Middleton, Tim 85, 117, 118, 120, 123

Motherwell, Sam 83, 86, 97

Parker, Cathy 116

Peirson, Barbara 9, 53, 75

Phillips, Clare 30

Preston, John 24, 107, 110

Prewett, Alex 41

Priaulx, Jennifer 103

Pye, Anna 114

Rapley, Sue 112, 114

Redpath, Ophelia 29, 62, 73

Rowe, Justin 68

Seddon, Jenny 81, map of Cambridge and endpapers

Smith, Sue 36, 49

Stark, Rebecca 34, 37, 74, 76, 96, 101, 105

Stemp, Isobel 8, 51, 66

Stone, Vanessa 70, 72, 113

Thomas, Glynn 64, 87

Tordoff, John 15, 44, 60, 83

Trestini, Rosemary 12, 23, 115, 119

Tunmer, Jo 32

Turner, Claire 48, 59

Villiers, Sonia 13, 19, 28, 52, 61, 102

Wiles, Colin 100